SPLIT SECOND

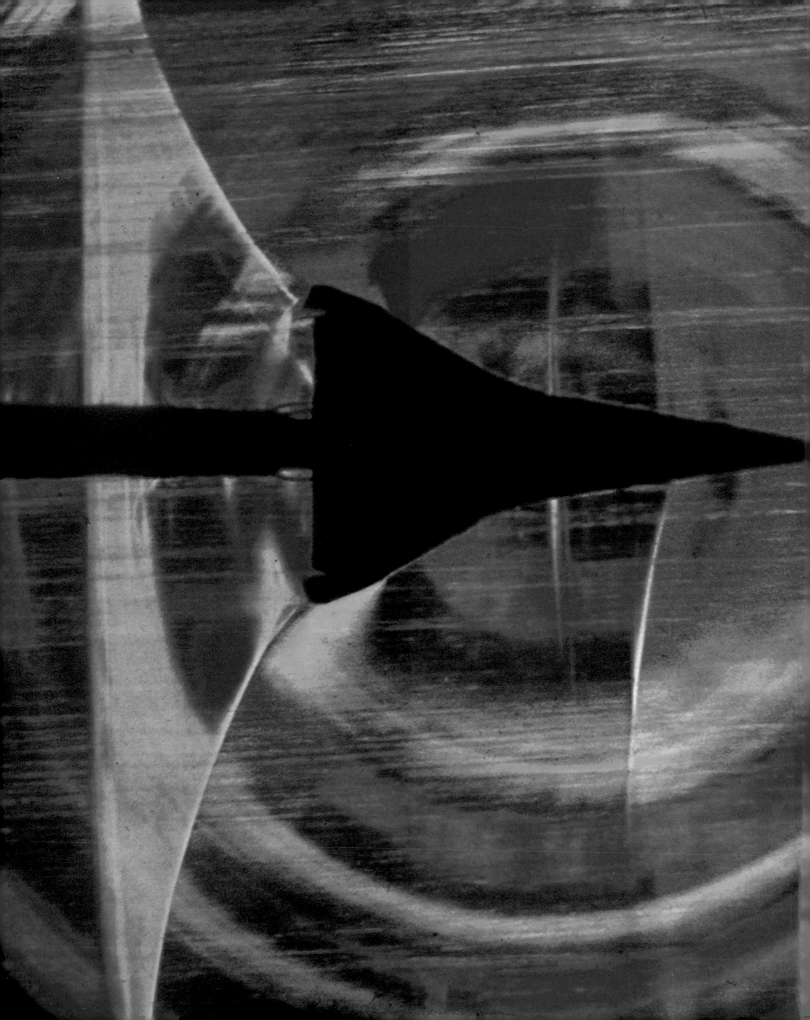

SPLIT SECOND

The World of High-Speed Photography

Stephen Dalton

Salem House
Salem, New Hampshire

First published in the United States 1984 by
Salem House, 47 Pelham Road, Salem, NH 03079
© 1983 John Calmann & Cooper Ltd

This book was designed and produced by
John Calmann & Cooper Ltd, London

This book was set in Great Britain by Modern Text Typesetting Ltd

Printed in Hong Kong by Mandarin Offset Ltd

ISBN 0 88162 063 7

Frontispiece
Shuttle wind-tunnel test
Originally shot to investigate the aerodynamic properties of the space shuttle, this photograph stands on its own pictorial merit. The startling abstract design and colour are produced by a technique known as dissection colour schlieren, which depends on the phenomenon familiar in mirages. As the air is deflected round the model aircraft in the wind tunnel, variations of air density occur. Put simply, high-speed flash and colour filters are used to show up these variations, although the details of the technique are complex. This picture is a plan view of the event (a profile view is shown in pl.139).

Contents

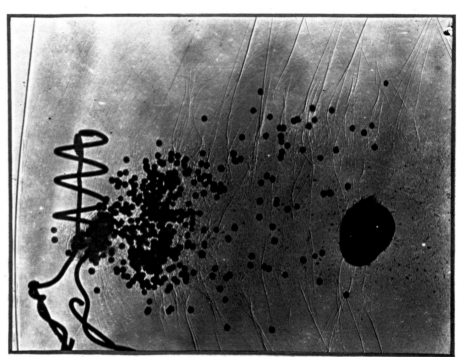

Fig. 1 A silhouette photograph of lead shot leaving a shot gun, taken in 1893 by Sir Charles Boys.

Introduction

Our eyes provide us with more information about what goes on in the world around us than all our other senses put together. They enable us to assess size, shape, distance, colour and beauty. Yet the human eye is hopeless at analysing movement—it can do so up to a point, beyond which individual movements blur into a continuous flow. This point is reached at a repetition rate of about ten 'pictures' per second. The eye is unable to work faster because the sensitive surface at the back of the eyeball, the retina, cannot receive and transmit impressions to and from the brain any more quickly. To make matters worse, the brain needs at least a quarter of a second to interpret a simple action—longer for a complex one. Such a rate was sufficient for early man's survival, allowing him to follow the approach of enemies and the movement of edible animals, but it is totally inadequate in our modern world.

Inquisitive man has long realized how slow his eyes were. How, he must have wondered, do birds use their wings to fly, how do horses gallop and how does a fly land upside down on a ceiling? The helplessness of the human eye to answer such questions became more apparent with the advent of fast-moving machinery and other technological developments. The actions of wheels, cranks, explosions and projectiles were either completely invisible or at most mysterious blurs. As science and industry advanced, our eyes became more and more inadequate, until high-speed photography was developed.

So what is high-speed photography? There is no precise point where 'normal' photography ends and high-speed begins. It might be said that any technique that records an event in a tenth of a second or less is high-speed. By modern standards this may seem absurd, but it should be remembered that during the nineteenth century most camera exposure times were measured in minutes rather than fractions of a second—thus 1/25 second was high-speed.

The term high-speed is relative. Nowadays it is possible to buy amateur cameras with shutter speeds of up to 1/2000 second, and flash guns delivering flashes that are even briefer. For most practical purposes true high-speed begins somewhere in this area—around 1/2000 second. The majority of the photographs in this book were exposed with still cameras and flash equipment operating at speeds of at least 1/5000 second.

The History of High-Speed

It may come as a surprise to learn that high-speed photography is almost as old as photography itself. In 1851, an English scientist, William Henry Fox Talbot (who invented the negative-positive system employed in modern photography), realized that he was unable to avoid blurring caused by motion, even in the brightest light available, sunlight. Even if he could develop a fast shutter, the emulsions were so insensitive, and the lenses so slow, that it was impossible to get a sharp image of a moving object.

It then occurred to him that if he set his camera up in a dark room with the shutter fully open, and illuminated his subject with a brief flash of light, he might overcome the problem. He decided to try to use the spark generated by a series of Leyden jars. A Leyden jar was a primitive form of high-voltage capacitor (a device capable of storing an electrical charge); it consisted of a cylindrical glass vessel coated with metal foil on both the inside and outside, the glass insulating the two foil surfaces. When it was charged with static electricity from an electrostatic machine, so that a sufficiently high voltage built up between the foils, a spark would jump across a gap between electrodes connected to each side. Although the amount of light produced was very weak, it was sufficient to illuminate small objects nearby. Moreover, the discharge time was in the order of 1/100,000 second. Fox Talbot staggered everybody by photographing a few square inches from a page of the *London Times* attached to a rapidly revolving disc—every letter was clearly visible. This was the first demonstration of high-speed photography. Fox Talbot concluded that 'it is in our power to obtain the pictures of all moving objects, no matter how rapid their motion may be, provided we have the means of sufficiently illuminating them with a sudden electric spark'.

Some ten years later the principle employed by Fox Talbot was used at Woolwich Arsenal, London, for observing the behaviour of projectiles in flight. The projectile was directed between the spark and the camera, and a silhouette of the object was recorded on a photographic plate. As the duration of the spark was about 1/1,000,000 second, theoretically an extremely sharp shadowgraph could be obtained, but photography was in its infancy in those days—only very low-sensitive wet plates were available—so these pioneering attempts were not particularly successful. Later in the century Ernst Mach in Austria and Sir Charles Boys in England made significant improvements in the technique, the basis of which is still used today in the study of ballistics.

The drawback to sparks, apart from their tremendous noise, is that the amount of light generated is totally inadequate for the illumination of large objects. But the idea of storing up a powerful electrical charge across a capacitor, and then releasing it suddenly at the right moment in the form of a flash, is the principle behind today's electronic flash and stroboscopes. But electronic flash photography did not escape the laboratory for another fifty years.

Meanwhile, with the improvement of emulsions, lenses and shutters, it became possible to take acceptably sharp photographs of moving objects in full sunlight. The earliest and best-known photographs taken in this way were of the famous 'Galloping Horse' by Eadweard Muybridge

Fig. 2 A running man, dressed in black with white bands, shown in 120 positions in the same shot. Photograph by E.J. Marey, after 1883.

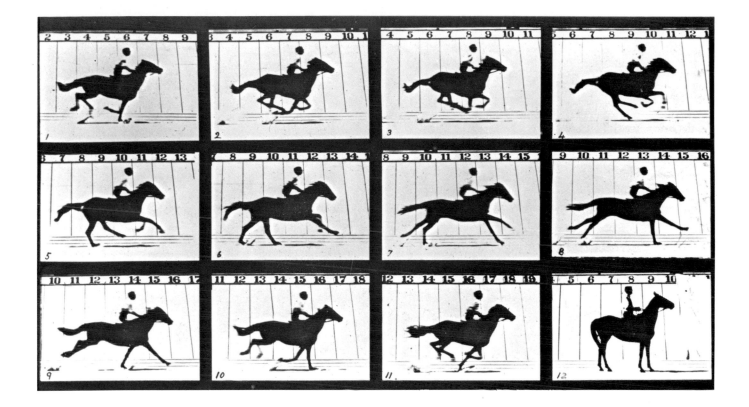

(Edward James Muggeridge was his full baptismal name). Muybridge was an adventurous Englishman who emigrated to the United States towards the end of the nineteenth century. He was an enthusiastic photographer, but where or how he learned the subject nobody knows. In California he met the railroad magnate Leland Stanford, founder of Stanford University and former governor of California. Stanford, a horse-lover, had got involved in an argument as to whether or not a galloping horse ever raises all four feet off the ground at the same time — he thought that it did. The story goes that Stanford wagered 25,000 dollars, and to back his hunch he commissioned Muybridge to take a series of photographs to prove it.

Muybridge was allowed to spend all the money he needed. He constructed a special rubber track to eliminate dust, with a white cotton screen on one side. On the other side he erected a 40-foot-long (c. 12-metre) camera house complete with darkroom. Inside, twelve cameras (and later twenty-four) were set twelve inches apart, each with a trip wire attached, so that as the horse moved forward it broke the wire and fired the shutter release. The shutter speeds used were in the region of 1/1000 second (very fast for those days). The resulting photographs were good enough to prove that a galloping horse did indeed momentarily raise all four hooves off the ground at the same time.

With the aid of faster films and lenses, Muybridge steadily improved his techniques, enabling him to photograph a wide range of active animals including men, women, ostriches and baboons. But although the slower movements were clearly recorded, the faster activities of some of his

Fig. 3 Galloping Horse. Eadweard Muybridge's famous sequence of photographs, showing that the horse does momentarily raise all four legs off the ground at the same time.

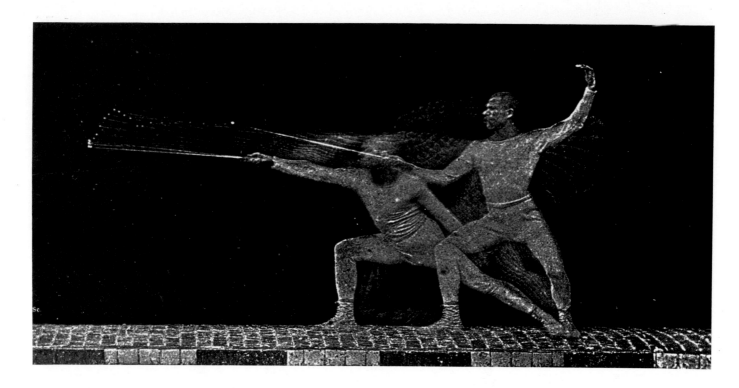

Fig. 4 and 5 Two photographs taken by E.J. Marey around 1895: a sword thrust (*above*) and a running dog (*right*). Like Muybridge, the French physiologist Etienne Jules Marey used photography to analyse animal movements. Muybridge and Marey kept each other acquainted with their techniques.

subjects were indistinct. Even sunlight could not provide enough light to expose his films at the high shutter-speeds needed. (Nowadays with fast mechanical shutters and fast films, it is a relatively simple matter to get well-exposed and sharp pictures of performing athletes and energetic animals.)

By the turn of the century standard mechanical shutters could arrest a wide range of rapid events, but they were (and are) nothing like fast enough to stop things such as driven golf balls and the wings of insects and birds, let alone bullets in flight. A fresh approach was needed and, as Fox Talbot had foreseen long before, it depended on a short burst of light.

Various attempts had been made to increase the brightness of electric sparks. Perhaps one of the most successful workers in this field was Professor A. M. Worthington, from England, who in 1900 took some pictures which revealed for the first time the transient beauty of splashing liquids and drops. But even his most powerful sparks were only just bright enough to light miniature sets. In 1929 the first flash-bulb appeared on the market, but as its light lasts many thousandths of a second, it could only be used for high-speed photography if combined with a high-speed shutter which opens and closes during a small part of the time the bulb is burning.

The first experiments with discharge tubes had been conducted at the Royal Institution, London, way back in 1821 — the idea of discharging a capacitor through a gas-filled tube being as old as photography. But the production of modern tubes was delayed for well over a hundred years until the problems concerning the development of gas-filled lamps for domestic lighting had been overcome.

The major breakthrough that led to the development of electronic flash

came in 1931. It was made by a graduate student in electrical engineering at the Massachusetts Institute of Technology, Harold E. Edgerton—later affectionately known as Papa Flash. His interest in high-speed flash came about as a result of a study of the reaction of electric motors to various loads. While experimenting with mercury arc-rectifiers, Edgerton noticed that while the arc-rectifiers were close to the rapidly revolving motor rotor, he could see the marked poles of the machine apparently oscillating from one side to the other. The arc-rectifiers just happened to be close enough for their flashing sparks to illuminate the rotor stroboscopically. Edgerton immediately recognized the scientific and commercial significance of the phenomenon, and so set his mind to design the first stroboscope.

In simple terms, a stroboscope is a repeating electronic flash. The pulsing light can be used either for visual observation or to record a sequence of pictures photographically on a single sheet of film, or the flashes can be synchronized with each frame of cine film. Modern stroboscopes can produce as many as 10,000 flashes per second.

Now followed some intensive development work, and to help him with this Edgerton gained the assistance of two colleagues, Kenneth Germeshausen and Herbert Grier, both M.I.T. electronic graduates. Briefly, their objective was to get the energy stored in a capacitor to discharge between electrodes contained in a gas-filled tube. Finding a suitable gas, or combination of gases, and establishing the right gas pressure, were vital for success. As a result of the team's cooperative academic efforts, and the entrepreneurial spirit that followed, their first electronic flash units were produced before the end of the decade. In 1939 came the publication of a fascinating series of high-speed flash photographs taken by Edgerton, demonstrating the potential of the new light source in both single flash and stroboscopic applications. Electronic flash had finally arrived.

One of the first photographers to realize the capabilities of electronic flash was Gjon Mili, who attended a meeting of the Boston Illumination Society where Edgerton was giving a demonstration of the new light. It is alleged that when Mili asked where he could get hold of some lamps, Edgerton replied: 'What will you do if I give you a set?' Without hesitation Mili said: 'I will quit my job and start the first strobe studio.' In a short while, and with Edgerton's support, Mili set to work in his uniquely equipped studio, and the pictures he created are to this day models of imagination and technical skill. His striking photographs, which were widely publicized in *Life*, range from sensitive human portraits to golf balls being flattened against golf clubs. Some of his most intriguing pictures were made by firing the flash repeatedly on to the same sheet of film, producing multiple images. 'For the first time', announced Mili, 'I realized that time could truly be made to stand still, that texture could be retained despite sudden violent movement.'

Electronic flash could be employed not only to serve its original purpose of stopping fast action, but also as a convenient and efficient light source for studios and a wide range of professional and scientific applications. During the Second World War, Edgerton's team built gigantic apparatus

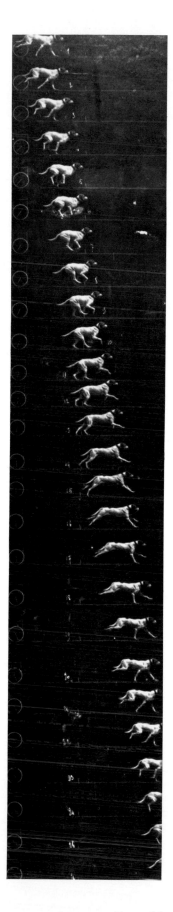

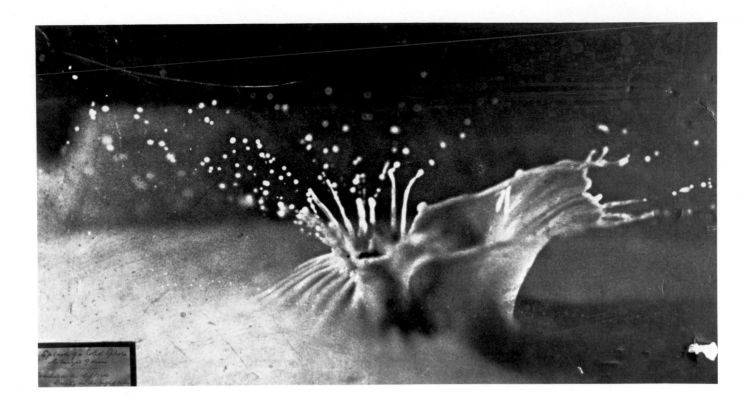

Fig. 6 A splash created by a solid object landing in milk, photographed by Professor A.M. Worthington around 1900. The illumination was provided by a flash from a Leyden jar.

for the United States Air Force for aerial photographic reconnaissance at night. In one unit, the D.5, the capacitors alone weighed one and a half tons, generating 48,000 Joules of energy. Its flash could illuminate the ground sufficiently well to take excellent photographs from altitudes in excess of 10,000 feet (3,000 metres)! In England too, the war effort stimulated the development of a wide range of specialized tubes and associated equipment for research purposes. One of the most important of these tubes was designed at the Armament Research Establishment for ballistic photography. The argon-filled tube of this ultra-high-speed unit could produce flashes with an effective duration of 1/1,000,000 second — short by any standards. Equipment of this type is still used today.

Modern Equipment

Nowadays an enormous range of electronic-flash hardware is made to cover a wide spectrum of professional and amateur requirements. But the instruments that can be used for serious high-speed work are few and far between. To understand why this is so, let us briefly examine the factors which affect flash speed.

The characteristics of electronic flash revolve around the capacitors which store the electrical energy, and the flash tubes through which this energy is discharged. The duration of flash, its power, the voltages required, and the size and weight of the apparatus are all keyed to these two components.

The basic relationship between light output and speed is quite simple. The larger the capacity of the capacitor, and the higher the voltage to

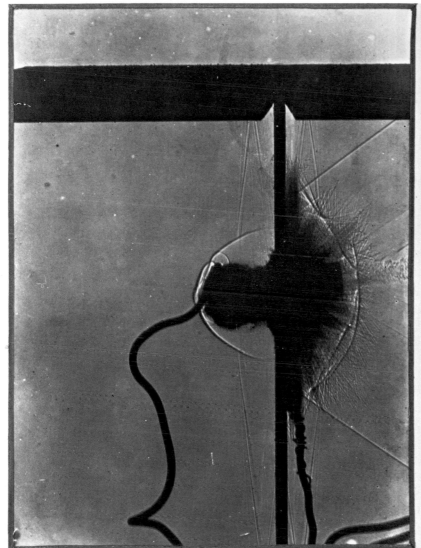

Fig 7 A 2,000-foot (*c.*609m)-per-second rifle bullet penetrating a sheet of glass, photographed by Sir Charles Boys in 1893.

8. *The same as N.° 7, but more advanced. The bullet is half way through the plate. The inclined air waves on either side of the plate give a measure of the velocity of the disturbance in the glass plate, and they shew that a transverse shiver radiated from the centre & was on the return journey of the reflection from the edge when the photograph was taken.*

which it is charged, the greater the stored energy. If capacitance is doubled, light output is doubled; if voltage is doubled, light output is quadrupled. Flash speed, however, is governed by the size of the capacitor, and the resistance of the flash tube and its circuit. So the larger the capacitance and the higher the resistance, the longer it takes for the energy to be discharged. To obtain short duration, it is necessary to find a tube of low resistance and, what is more important, to use a small-value capacitor.

This explains how brief flashes can be obtained from computer flash guns. When one of these units is fired, a light sensor detects and measures

the illumination reflected from the subject. As soon as sufficient light has been produced, a quenching circuit instantly extinguishes the flash. In this way only a portion of the stored energy in the capacitor is used — the actual amount depending on subject distance and other factors. Moreover the discharge time is reduced proportionately. For example, a computer flash unit which say at full power delivers 50 Joules of energy and 1/1000 second, only produces 3 Joules and 1/16,000 second when operating at 1/16 power — probably little more output than that from the sparks some eighty years ago.

The only way to get both speed and power is to use a small-value capacitor and charge it to a high voltage. But high voltages dictate paper capacitors. Much of the early portable equipment employed relatively small paper capacitors which were charged to 2,000-3,000 volts, and had a flash speed of about 1/5000 or faster. However as soon as electrolytic capacitors were developed, speeds became much longer — around 1/200-1/1000 second — quite useless for arresting rapid movements. Take, for example, the wing-tip movement of a humming bird which can move more than 10,000mm per second. To confine this blurring movement to 1mm, let alone to freeze it completely, the exposure time should be no longer than 1/10,000 second. Practically all modern flash equipment uses electrolytic capacitors rather than the 'old-fashioned' paper variety, because they are smaller, lighter and cheaper.

Almost from its inception, those quick enough to grasp the potential of electronic flash for arresting movements exploited its unique advantages to the full. Apart from pictorial considerations and the sheer fascination of seeing an invisible event frozen in a photograph, high-speed photography is an invaluable tool in science and industry. It can be employed to observe and measure velocity, acceleration, distortion and all manner of other transient events. Often highly specialized flash units are needed for such purposes; for instance, equipment operating in the region of one microsecond (=1/1,000,000 second) is essential for the recording of bullets and projectiles and the study of aerodynamics of propellers and supersonic aircraft. Short-duration flash is used in the study of droplets and their distribution in jet engines and other machines which rely on spray atomization. Special high-speed flash is frequently used in the research into bubbles and cavitation (underwater bubbles). Pulsed ruby lasers are powered by special flash tubes. The bursts of energy from these devices are at least 10 billion times brighter than the early steady-state lasers, and can emit light in flashes of billionths of a second. A high-speed flash of light is often needed for schlieren photography (which detects and makes visible local changes in density in transparent materials) to arrest shock waves and the ephemeral movements of gases and liquid, and for more actively turbulent subjects such as the fiery exhaust from jet engines.

There are some subjects which defeat the fastest electronic flash. High-velocity bullets, for example, may streak through the air at well over the speed of sound, and can only be arrested by the flash generated by the 'old-fashioned' spark. Lasting about ten billionths of a second, the light generated by modern spark equipment is too weak for normal

photography but is bright enough for shadow pictures as the bullet passes directly between the spark and the film.

Other ultra-rapid events may not need flash at all as they produce so much light of their own. The difficulty here, though, is to find a shutter which opens and closes for a mere millionth of a second or less. A mechanical shutter is quite hopeless due to the time taken to overcome the inertia of the various moving parts. One answer is to use an electro-optical device such as the Kerr Cell, named after the Scotsman John Kerr. He discovered in 1875 that when certain substances are subjected to an electric field, their molecules will align themselves in such a way that light waves passing through become plane polarized (vibrate in one plane).

The Kerr Cell shutter consists of a glass tank filled with a liquid which can be polarized, such as nitrobenzine, sandwiched between two glass polarizing screens. The shutter is set up so that under normal conditions the cell is opaque, but as soon as a powerful electric field is applied, the plane of polarization of the liquid is rotated, allowing a proportion of the light to be transmitted. Shutters using this principle, or a similar one employing glass rather than a liquid, are capable of opening and closing in a few nanoseconds (one nanosecond=1/1,000,000,000 second). The photograph of a nuclear explosion (pl.3) was recorded in this way.

High-Speed Motion Picture Cameras

Although this book is largely about still photography, several of the plates have been reproduced from single frames of cine film. There is nothing to compare with a single-exposure camera for maximum image-quality, which is just as well since a still photograph has to withstand long and close scrutiny. But it does suffer from one obvious disadvantage—it cannot show how an event starts, how it builds up and how it dies away. This is the domain of the motion-picture camera.

A cine camera works by winding the film rapidly between exposures. If the resulting pictures are passed through a projector at the same speed at which they were taken then, due to persistence of vision, the impression of continuous movement in normal time is obtained. Because motion pictures are taken on a time basis, it is also possible to manipulate time— at the taking stage. A motion-picture camera normally operates at 16 frames per second (f.p.s.) and the resulting film is usually projected at 16 f.p.s. However, if projection frame-rate is kept constant and the camera frame-rate is altered, then time scales will be distorted. By decreasing camera frame-rate, time will appear to be speeded up. By increasing camera frame-rate, time will apparently be slowed down. The first possibility—time-lapse photography—enables time scales of minutes, weeks or years to be compressed into seconds. The second possibility—high-speed photography— enables time scales measured in perhaps milliseconds to be expanded into seconds. For example with a projection rate of 16 f.p.s. and a camera speed of 64 f.p.s., movement will be slowed down by a factor of four. Thus one second of real time will be expanded to four seconds—a modest beginning to high speed.

Whereas high-speed still photography can be carried out with almost

any single-frame camera, high-speed cine work needs highly specialized and enormously expensive camera equipment. It is possible to buy a movie camera off the shelf which will operate at up to 72 f.p.s., but this will not provide true high-speed. True high-speed movie photography is considered to begin at frame rates of 100 f.p.s. (there are cameras available which can shoot at over 500 million f.p.s. but such equipment is highly specialized). Let us take a brief look at the various types and see how they work.

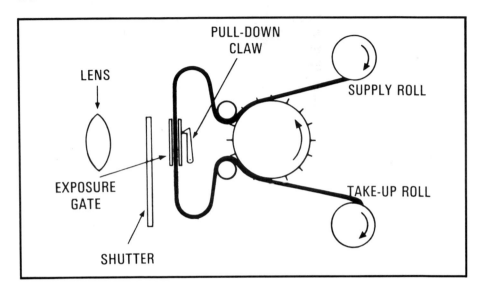

Fig 8 The mechanism of an intermittent pin-registered camera. The film is moved into the gate by the pull-down claw. The claw then retracts and a pin inserts into one of the perforations to hold the film steady during exposure.

Intermittent Pin-Registered Cameras

These work on the same principle as the conventional motion picture camera. The film is pulled down into the gate by a claw, which fits into the perforations at the edge of the film. When the film is in position, the claw retracts and register pins are inserted into the film perforations to hold the film steady while the shutter opens and closes. This operation produces an extremely sharp image. Unfortunately, because of its complex mechanical nature, it also limits the speed at which the camera can work. Maximum speed is normally 500 f.p.s., although a few can operate up to 1,000 f.p.s.

Pin-registered cameras have many advantages over other high-speed movie cameras: the image quality is unparalleled, light transmission efficiency is high and film is used up at a slower rate, allowing a longer recording period. Against this, however, must be set the slow maximum framing rate. Although shutter speeds in excess of 1/100,000 second can be achieved, it is the space between frames which becomes the governing factor. Some events will actually start and finish during the period between closing and opening the shutter.

Rotating-Prism Cameras

Rotating-prism cameras are capable of a much faster frame-rate than the pin-register variety (anything up to 25,000 f.p.s.). In order to obtain this higher frame-rate, the film is kept moving continuously through the camera. A prism which is situated between the lens and the film also rotates con-

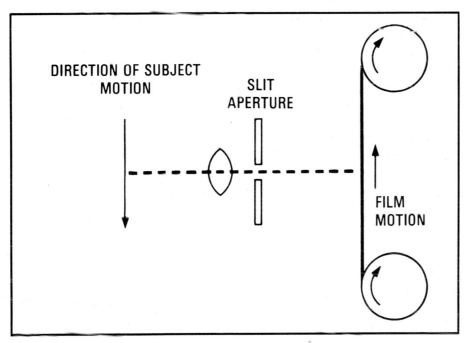

Fig. 9 In a rotating-prism camera, the prism block alternately blocks and passes light from the subject to the film. The prism block and the film are synchronized so that the relative motion between the image and the film during the exposure is zero.

tinuously. As it does so, it alternately transmits and blocks light passing through the lens from the subject. Because film and prism are moving in synchronization, however, relative movement between the image and film is zero. Some rotating-prism cameras incorporate a shutter. This is fitted between the prism and the film plane and provides an efficient means of controlling the amount of light reaching the film. It also allows exposure times to be varied. The result is improved definition and a better-defined framed boundary.

Rotating-prism cameras offer the advantages of a higher frame-rate, shorter exposures, and shorter intervals between exposures. However, they also offer poorer image quality, and short recording times (owing to the higher frame-rate). Some rotating-prism cameras have an additional feature. With slight modification they can be converted into streak cameras. This brings us to our next classification.

Fig. 10 In a streak camera, an uninterrupted slit-image is swept across the film which is moving at a right angle to the motion of the subject. Such a technique is used in synchroballistic cameras to study ballistic projectiles.

DIRECTION OF SUBJECT MOTION

SLIT APERTURE

FILM MOTION

Streak Cameras

Beyond the realm of intermittent pin-register cameras and rotating-prism cameras there lies the world of the streak camera. So far we have been talking about 'framing' cameras—where the resulting film exhibits a series of sequential photographs or frames. The streak camera does not record individual pictures of an event. Instead, an uninterrupted slit

image is swept across the film. These cameras are unmatched by any other instrumentation in their capacity to provide extremely accurate velocity measurements of transient events.

Streak cameras can be divided into two major groups: moving film types such as the camera discussed in the preceding section where the rotary-prism unit is replaced with a slit; and rotating-drum and rotating-mirror cameras which employ a fixed length of film held stationary on the inside of fixed track or a rotating drum. Most of these latter types operate at extremely high rates and that classifies them as ultra-high-speed cameras. We will look at them next.

Ultra-High-Speed Cameras

Ultra-high-speed cameras do not normally produce films of the variety that are projected on a screen. Instead a number of sequential pictures or a streak record is produced on a short length of film which may be only a few feet in length.

Rotating-mirror and rotating-drum cameras operate within the range of about 20,000 pictures per second up to more than a million pictures per second. In a rotating-prism camera, the maximum speed is limited by the resistance to fracture or flexure of the moving parts. To overcome these limitations, a spinning mirror made of a very high-strength material, such as beryllium, is driven by means of a turbine and compressed air and the image is swept over a piece of film that is fixed in place. In order to attain even higher speeds the mirror chamber can be evacuated so that the friction of air is eliminated. The turbine, too, can be driven by compressed helium which is much lighter than air. Rotating-mirror and rotating-drum cameras have the advantage that the mirror or drum can be brought up to speed and maintained at a constant rotation before the event is initiated. Thus, not only is a continuous time/displacement record obtained but the time scale is uniform throughout the record.

Image-converter cameras rely on the formation of an image on a photocathode which is electronically displayed on a larger fluorescent screen at the end of the tube. This amplified image is then photographed by a camera. These are really electronic cameras in so far as it is an electron beam that forms the useful image. Being an electronic device the exposure can be controlled down to about 1 nanosecond and magnetic deflection of the electron beams makes it possible to move the picture on the screen so that several pictures may be obtained at extremely short durations and intervals. These devices make possible recording rates from 50,000 to 600 million pictures per second.

Image-converter cameras offer the advantage of high light-amplification (which means that events of low brightness can be studied), adjustable frame-rate and interval spacing, and extremely high-speed exposure and picture frequencies. Against this, the picture quality does not compare with the more conventional cine cameras.

Practical Points

As it is so expensive, high-speed movie photography is not a field that can be tackled by the amateur. The equipment alone will cost upwards

of £10,000 while the film consumption can only be described as prodigious —frequently hundreds of feet per second.

Synchronization is generally easier with movie because it is difficult to miss the action when several thousands of pictures are being taken every second—that is if the timing of the event can be controlled or anticipated. A difficulty arises when the event occurs unexpectedly, because most high-speed cameras take a second or two to build up speed. During this time the action may well have ended, or just as likely, not even started!

High-speed still photography is a much more fruitful area for the amateur to explore. To begin with, the majority of subjects can be undertaken with almost any stills camera in conjunction with a suitable flash unit. Computer flash guns are quite satisfactory for subjects which are not too large and which do not move too rapidly. The chief difficulty lies in synchronizing the flash with the event—capturing exactly the right moment on a single frame of film can be tricky, and generally means making up suitable circuits.

Various types of sensing devices can be used for detecting the object or event, either mechanical, optical or acoustic. Noisy subjects such as bursting balloons are best photographed using an acoustic trip, when a microphone picks up the sound and fires the flash via a small amplifier. Most shutters take from between 1/10 and 1/20 second to open so that by the time the flash fires the fleeting event will have long passed. So it is often best not to use the camera shutter at all but to work in the dark with 'open-flash' technique, in which the shutter is locked open before the flash is fired. Most of the photographs in Section I were obtained in this way.

A more versatile trip is the optical type, where a narrow beam of visible or infra-red light is directed on to a photoelectric cell and an amplifier senses the instant the beam is broken. With suitable optics and electronics, anything from an elephant to a midge can be detected. Again, shutter delay is often a serious problem, and open-flash technique or ancillary rapid opening shutters may be needed. Optical triggering was used in the majority of flash photographs through this book.

Although some of the photographs included here are chance shots taken with available light, the majority are the result of much painstaking work, conducted perhaps over several days or weeks and employing highly sophisticated equipment and techniques. However, they all have one thing in common: they are a record of events normally unseen by the human eye, caught within a split second.

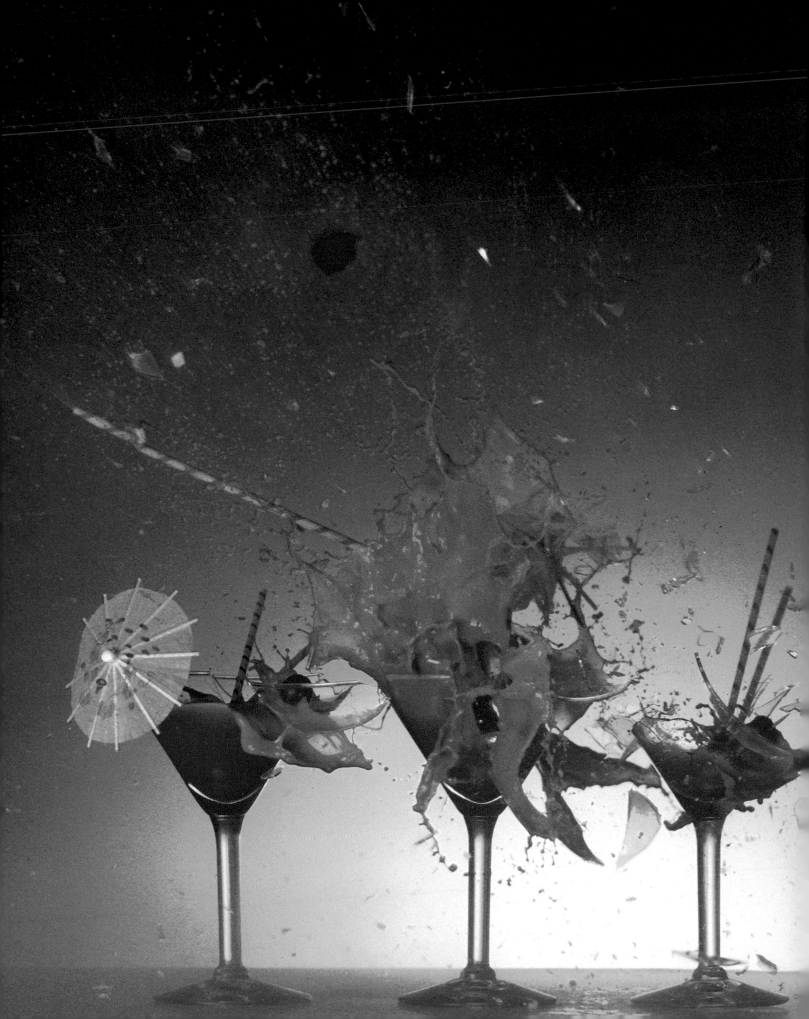

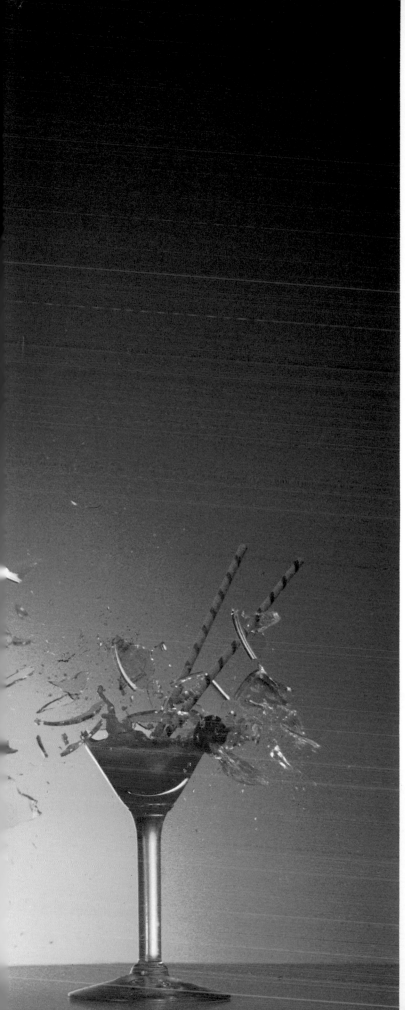

1 Impact

2 Exploding cocktail glasses
Bizarre images are in vogue for pop-music record sleeves.
This photograph was used on an album cover for the *Sad
Café*. A bar top and a gross of cocktail glasses were taken
to Wembley Rifle Club, where the glasses, filled with
wine, were systematically destroyed by ·22 bullets. The
photographer used electrical contacts to achieve
synchronization. By the time the assignment was
completed, there was so much wine splattered around
that the place had to be redecorated.

Opposite
3 The ultimate malevolence
A silent nuclear fireball devours the air
over the Nevada Desert. At this point
the ball is distorted by the heavy
materials of the bomb's detonating
mechanism. Neither sound nor
shock-wave has yet emerged and
nothing has burnt, melted or
collapsed. The tower on which the
bomb was placed remains intact — but
in another millionth of a second the
fireball will grow into a smooth greedy
sphere, expanding at thousands of feet
per second, and vaporizing matter
instantly. The landscape will be lit up
by its fierce glare, many times brighter
than the sun.

Professor Harold Edgerton developed
a special camera protected by
elaborate shutter mechanisms to
record the first moments of the
explosion. The first shutter opened
mechanically one second before
detonation, and was followed by an
electronic shutter which exposed the
film for a few millionths of a second.
But this alone was not sufficient; even
though the camera was ten miles from
'ground zero' a third shutter had to be
added to prevent the film from being
fogged by the fireball's light. This
shutter consisted of a glass plate
criss-crossed with thin lead wires
which were vaporized by a pulse of
electricity so that an opaque coating of
lead guaranteed the film's safety.

By far the most rapid movements known are those resulting from explo-
sions. Projectiles from guns, for instance, flash through the air at speeds
of between five hundred and several thousand feet per second, although
even these are sluggish compared with the activity originating from
some nuclear reactions. Whereas many of these more leisurely phenomena
can be frozen with short-duration electronic flash, some of the faster ones
can only be arrested by employing highly specialized and expensive
equipment such as streak cameras, image-converter cameras and Kerr
Cells.

The variety of subject-matter included within the next pages has been
recorded by all manner of techniques and equipment. While some of the
pictures were taken by highly skilled professionals in research establish-
ments, others are the work of amateurs in makeshift home studios.

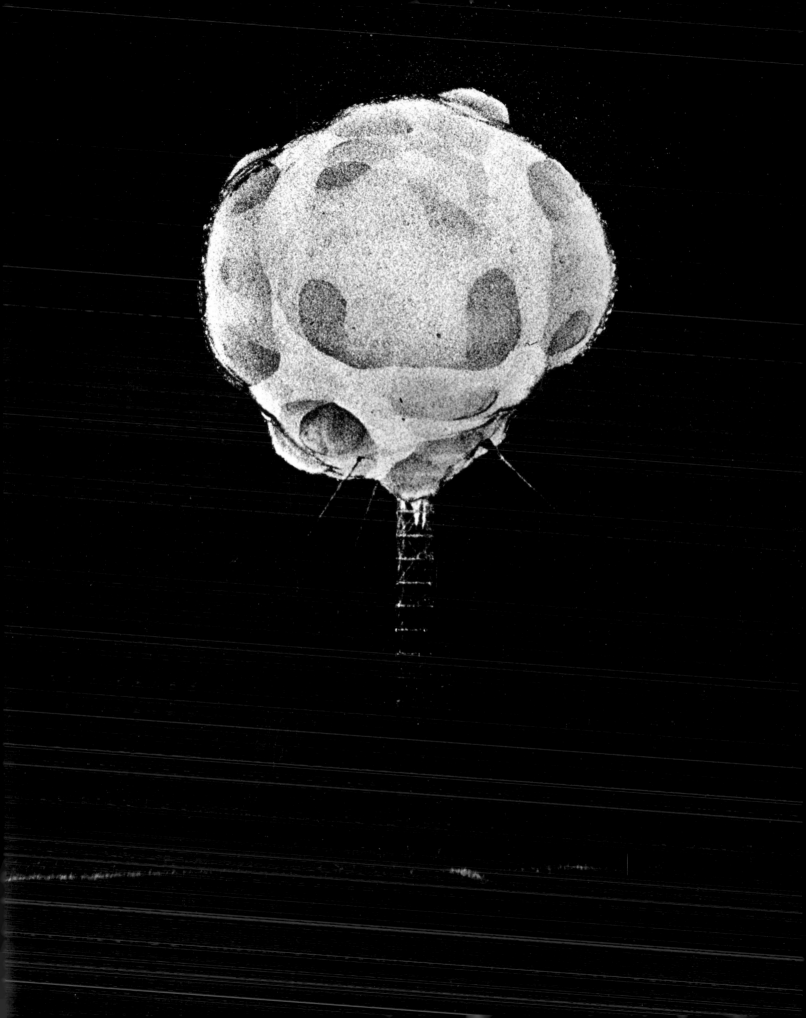

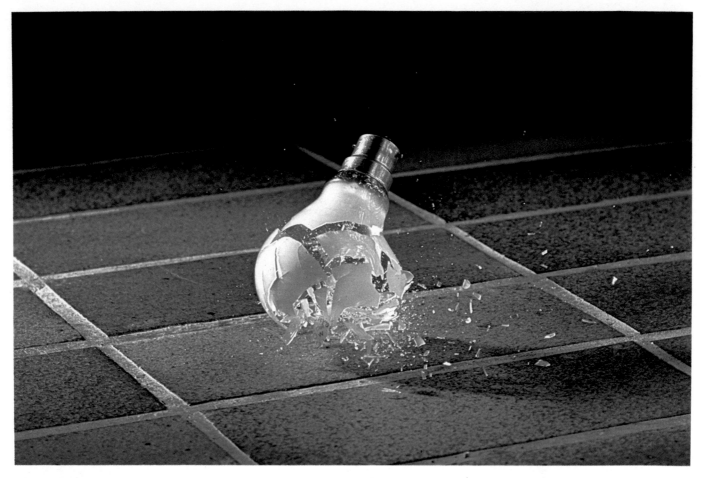

Shattering light-bulbs

4 This light-bulb has just been dropped from a height of seven feet (2.13m) on to a hard stone floor. Note that although the glass envelope has shattered the bulb's shape is still easily discernible. A split second later and the whole thing will have imploded—already many of the smaller fragments of glass have been sucked into the bulb's interior.

There were a number of occasions during the photography when the bulb did not break at all—it just bounced back into the air!

Opposite

5 Far from being a simple, high-speed photograph of an exploding light-bulb, this is an ingeniously contrived shot.

Prior to being smashed by an airgun pellet, the bulb was subjected to extensive surgery. The bulb was snapped off at the base and was carefully cracked; then an area of the front was removed and the filament replaced with a handmade version in thicker wire, powered by a transformer. The glowing filament was then exposed for several seconds through a soft-focus filter, and the top of the bulb was replaced. The final step was to shoot the bulb, an acoustic trigger and a delay unit being used to obtain two separate flashes. The first flash exposure had a duration of 1/200 second which accounts for the blurred yellow trace of the shattering glass; the second exposure lasted about 1/10,000 second, freezing the movement.

It took two weeks to obtain this result, during which time fifty light-bulbs were destroyed.

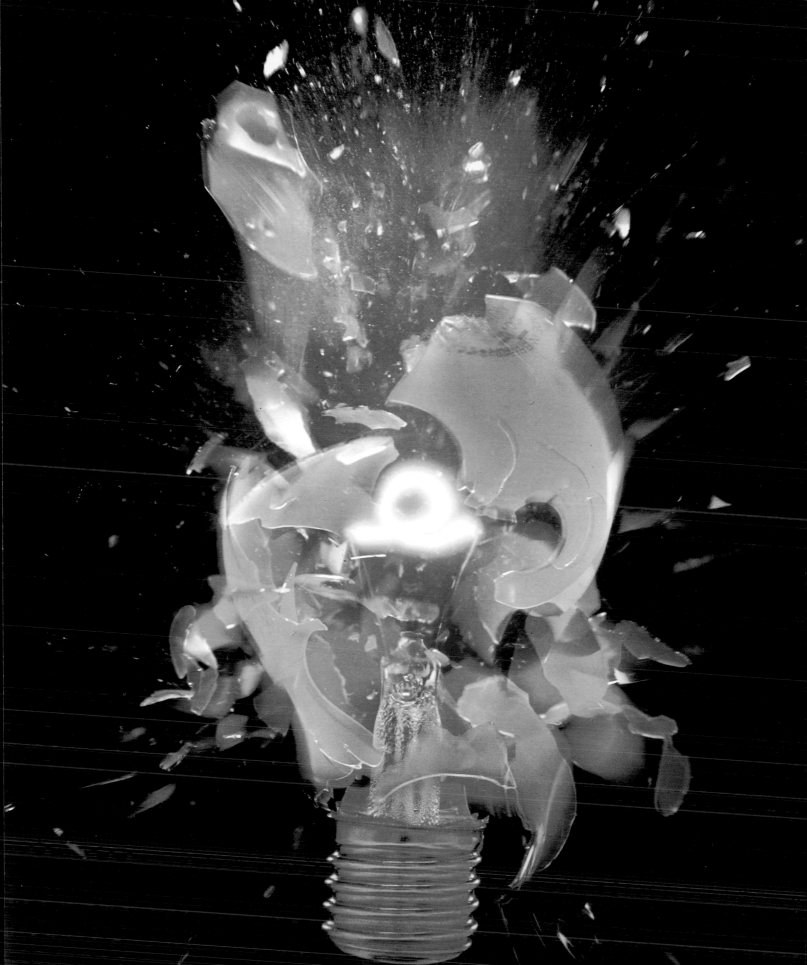

Extinction

6 As a rapidly descending hammer makes impact with the light-bulb, cracks radiate from the point of contact. A moment later the bulb was reduced to fragments. The flash was triggered by the sound of the initial impact—the microphone can be seen held an inch or so away from the bulb at the top right of the picture.

7-10 The action shown in these four pictures lasted in all for a mere 1/30,000 second, each one being exposed in 1/1,000,000 second. However, the photographs were taken in succession with different bulbs and bullets used each time.

In pl.7 the bullet is cruising along at over twice the speed of sound. As it enters the bulb (pl.8), the cracks can be seen to be moving faster than the bullet itself. In pl.9 the other side of the bulb has started to crack well before the bullet arrives as a result of the 15,000-feet (4572m) per-second compression wave. The final picture (pl.10) shows the bullet several inches away from the bulb. The bullet is just emerging from an arrowhead formation of glass, dust and gas.

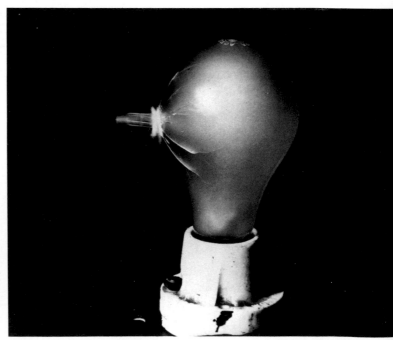

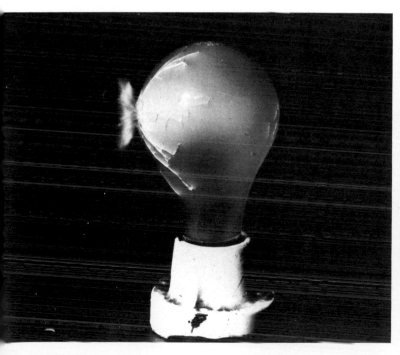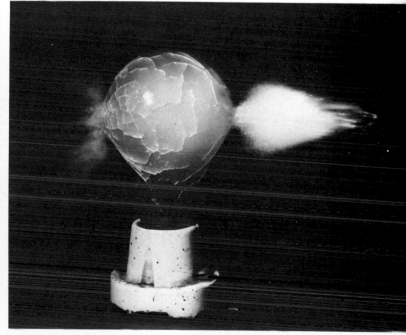

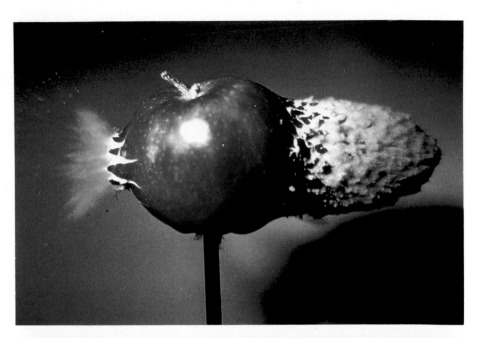

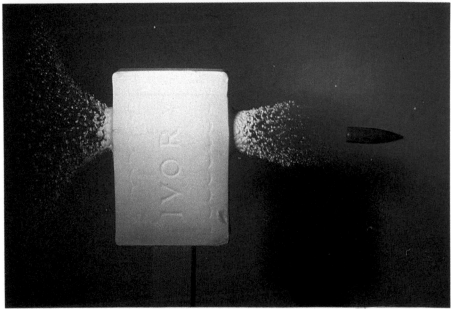

**11-13 Apple, soap and
playing-card**
As bullets can move at several
thousand feet per second, well above
the speed of sound, an extremely high
flash speed is needed to arrest all
movement. These pictures were
exposed at around 1/1,000,000
second.

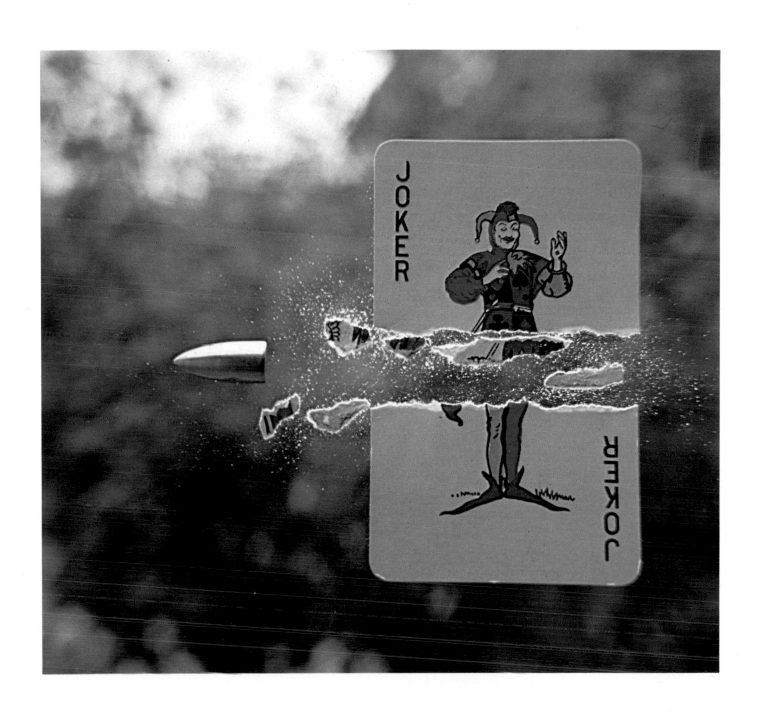

Bang!

Below

14-16 A Hauser automatic is fired. Compare this sequence with that of the 1878 revolver *(right)*. In pl.14 the bullet has just left the barrel, but is still behind the leaking smoke. In pl.15 it is drawing ahead of the charge while in pl.16 it has overtaken all the smoke and gas. The recoil of the gun can be clearly seen by comparing the position of the muzzle in each picture. Exposure was around 1/1,000,000 second.

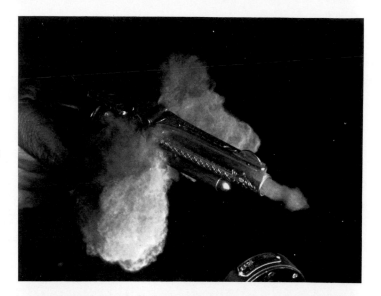

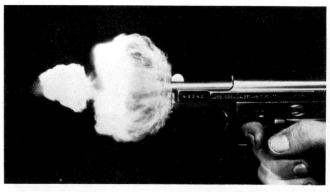

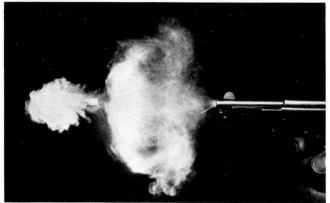

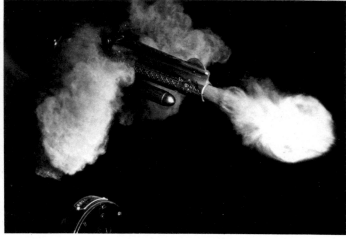

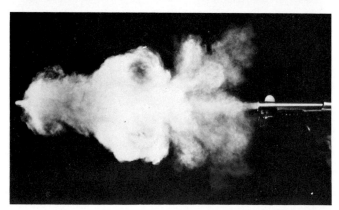

Above

17, 18 When an antique revolver is fired, a cloud of smoke billows out on each side of the cylinder. In pl.17 the charge has gone off, but the bullet has not yet reached the muzzle. A split second later, the bullet has come and gone, leaving gas and smoke from the propelling charge issuing from the muzzle. The exposure time was 1/1,000,000 second.

Opposite

19 Bullet and Plexiglass

A high-energy spark was used to take this schlieren silhouette photograph of a ·30 calibre bullet as it smashes through a sheet of Plexiglass. A 1/1,000,000 second spark was used to stop the high-velocity bullet (moving at 2,800 feet—*c.*853m—per second).

In photographs of this kind, the flash is normally triggered by the shock-wave, but in this case note that the shock-wave has not yet reached the microphone at the bottom of the picture. Instead, the flash was fired by a faint shock-wave travelling down the Plexiglass and out to the microphone. (Sound travels ten times faster in Plexiglass than in air.)

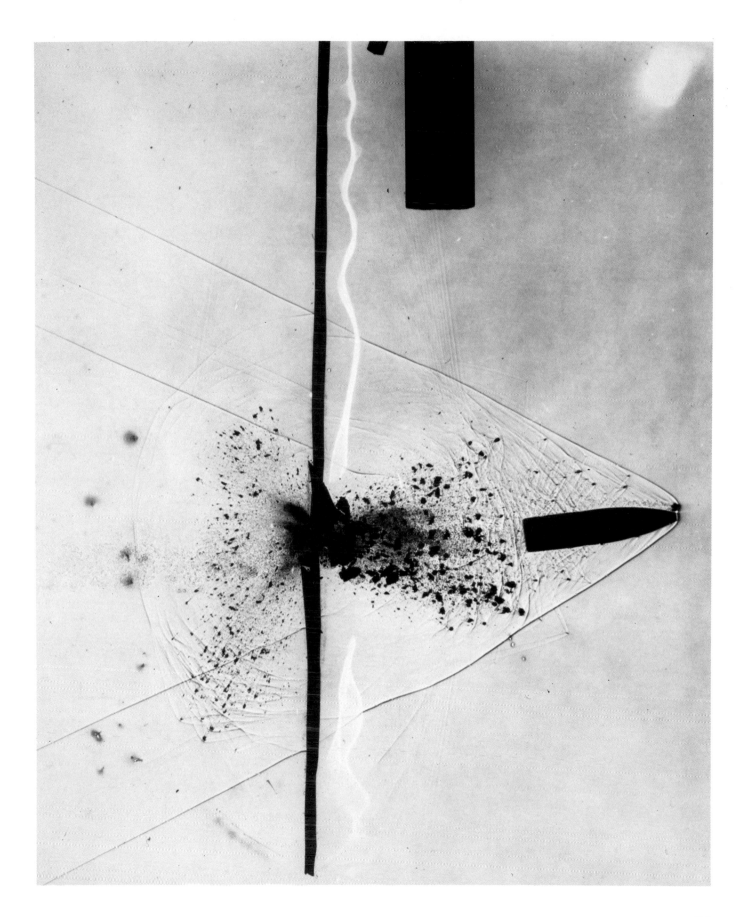

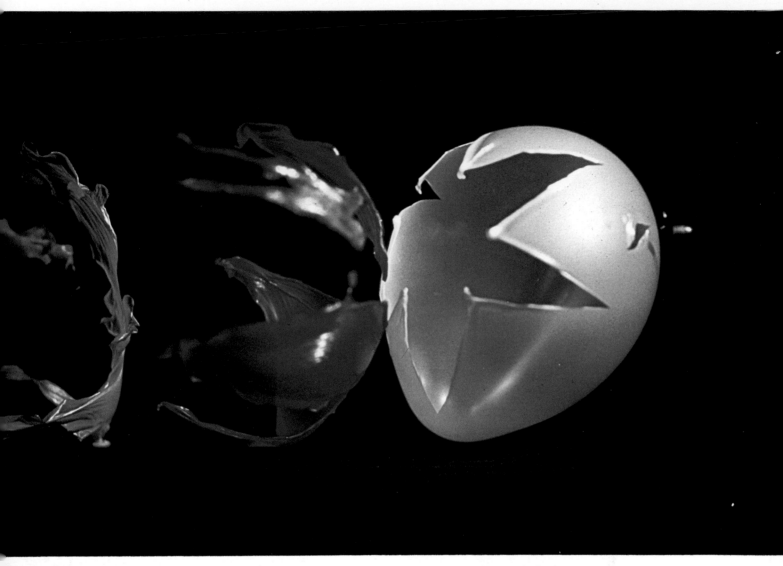

20 Bullet piercing balloons
Travelling at 1,200 feet (*c*.366m) per second, a ·22 rifle
bullet rips through three balloons. The balloons are seen in
successive stages of disintegration, each one peeling back
before being reduced to shreds. The bullet can be seen
leaving the yellow balloon to the right.

Opposite
21 Supersonic bullet
Much information is contained in this high-speed colour
schlieren photograph of a supersonic bullet passing through
the hot air rising above a candle: the picture is not merely a
silhouette of the bullet, but a record of the resultant
shock-waves and the range of temperatures around the
candle.

Schlieren photography works by showing up differences of
refractive index (density) in gases or liquids. In this case the
various densities are displayed in different colours.

32

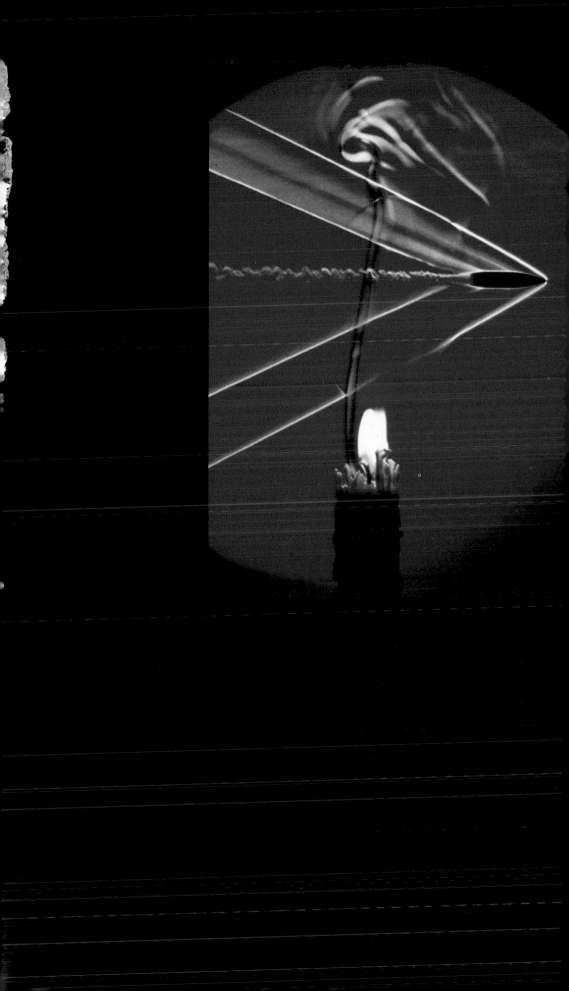

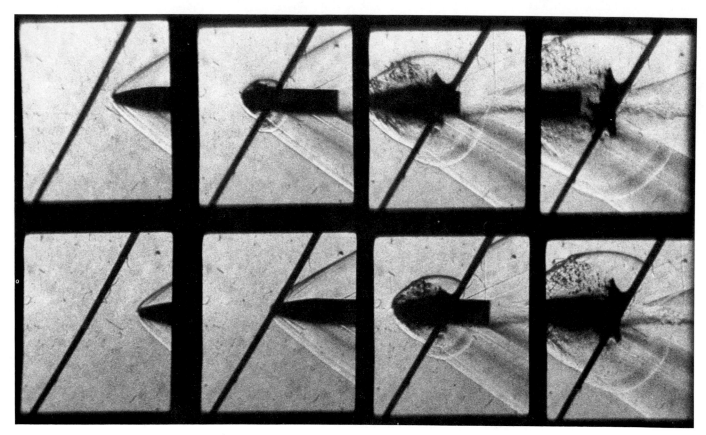

22, 23 Impact
These photographs were obtained by employing highly specialized optics and synchronizing techniques in conjunction with image-converter camera systems, where the image is formed on a photo-cathode and displayed electronically on a fluorescent screen (see Introduction). In pl.22 schlieren techniques were needed to show a bullet penetrating a soft target—in this case a framing rate of 100,000 frames per second was used. In pl.23 a lead airgun pellet smashes into a hard object—also at 100,000 frames per second.

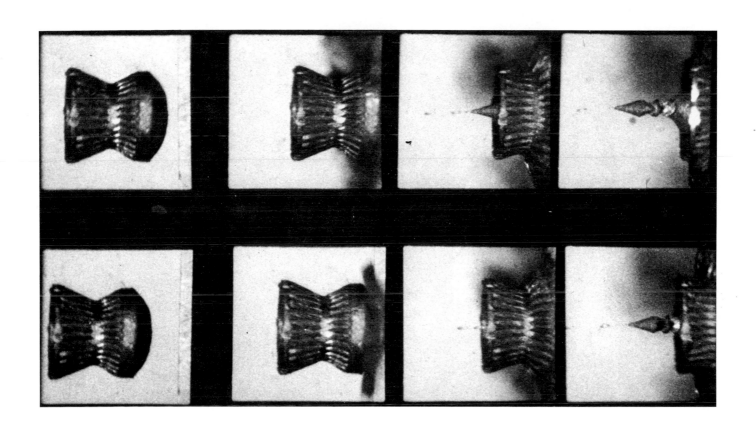

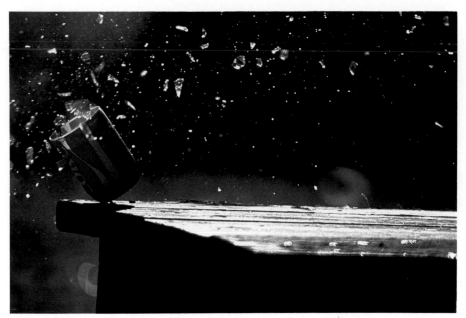

24 Shattering bottle
Arresting pictures can be obtained by employing the high shutter speeds available on single-lens reflex cameras. Here a speed of about 1/2000 second was used to capture the moment when a bottle is shattered.

Stop-action pictures such as this are a challenge to the ability of mechanical shutters—and to the photographer's reflexes. Because of the 1/10 second of human reaction time, together with the 1/20 second it takes for a mechanical shutter to open, the shutter release has to be pressed well before the event takes place.

Opposite
25 Exploding sherry-glass
A glass of sherry disintegrates as an airgun pellet passes through it at 500 feet (*c.* 152m) per second. The pellet can be seen leaving the glass on the right of the picture.

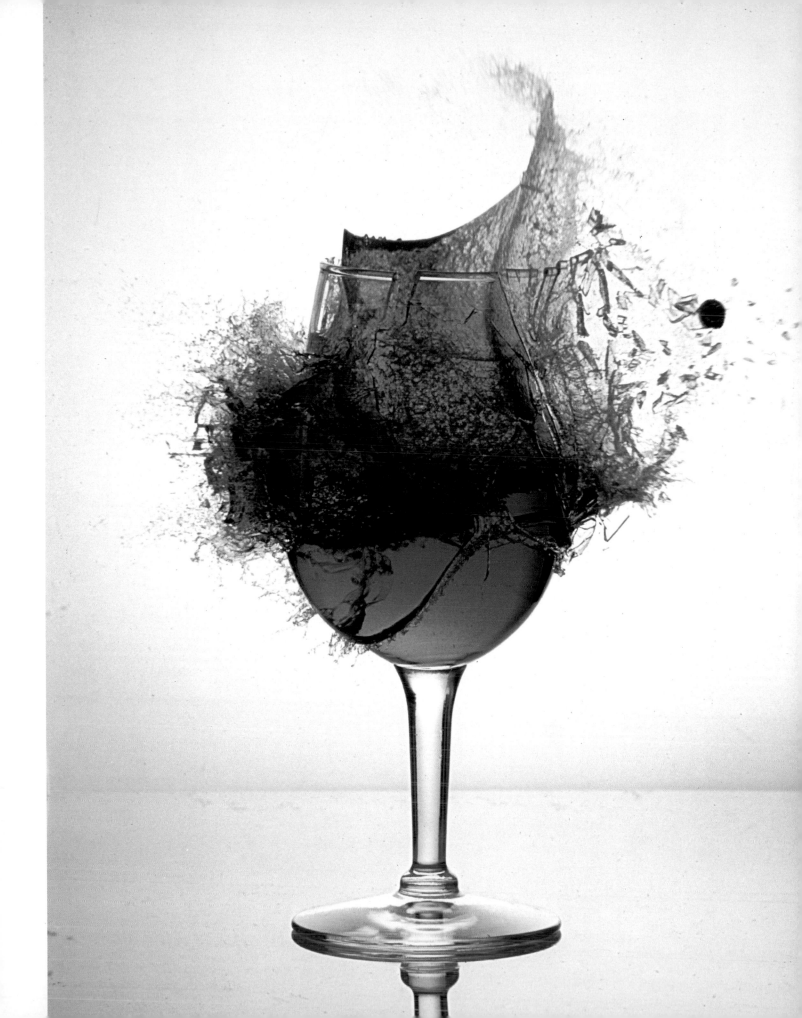

26-29 Bursting balloons
Sonic triggers were used to capture the moment as these balloons burst. In pls.27-29 the various stages were recorded simply by adjusting the distance between the microphone and the sound source. The further the microphone is from the balloon, the longer the delay between the bang and the flash (at sea-level, sound travels at about one foot — c. 32cm — every 1/1000 second). In pl.26, the flash speed was 1/2,000,000 second; in pls.27-29 it was 1/25,000 second.

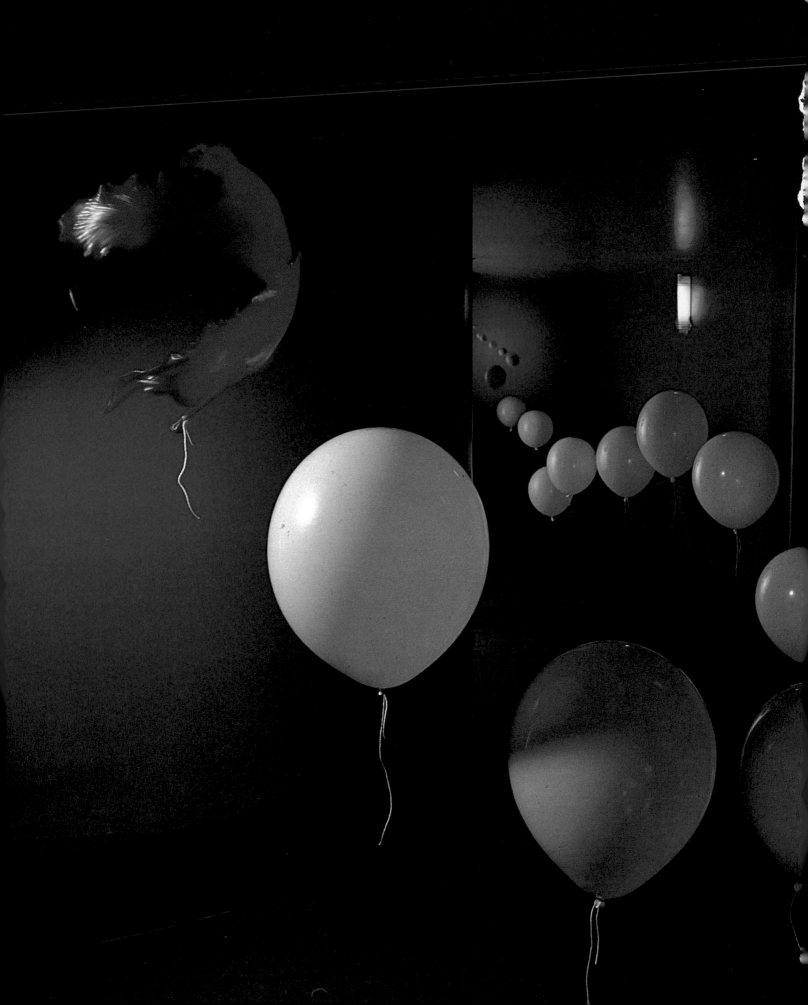

30 Floating balloons
This was another commission for a record-sleeve. In a large studio set, the balloons were suspended by fine nylon threads or attached by rods at the back. An airgun pellet was used to burst the red balloon, synchronization being achieved by means of electronic contacts on a swinging arm. Timing the burst proved a headache—it took a week and twenty boxes of Polaroid film to make the technique work!

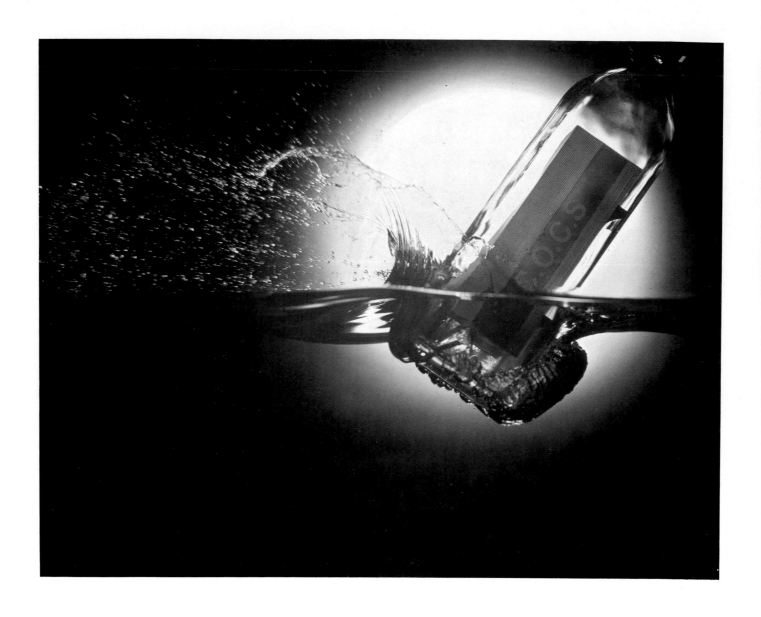

Dropping a bottle and cup of coffee

31 Many of the larger studio flash units produce very slow flashes, as can be seen in this photograph where the drops of water show considerable image movement. The flash speed was probably around 1/400 second—a modern focal plane shutter would have done better. From a pictorial point of view, however, a little blurring can often enhance the image.

32 It is interesting to note that, as the cup shatters, the fragments have shot some distance from the coffee, and yet much of the liquid still retains the shape of the cup.

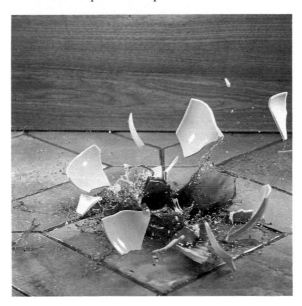

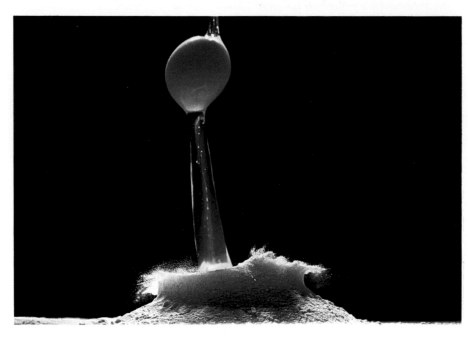

33 Making batter
An everyday domestic activity frozen at 1/3000 second.

Opposite
34, 35 Champagne christening
Another example of advertising photography, these pictures illustrate two stages in the destruction of a bottle of champagne. The flash did not quite freeze the movement of the erupting liquid.

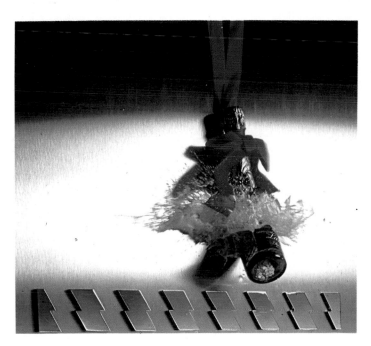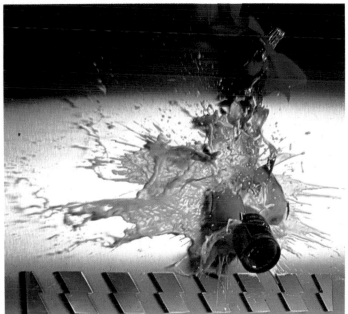

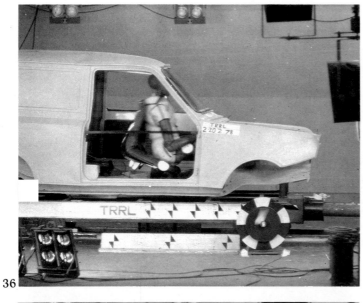

36

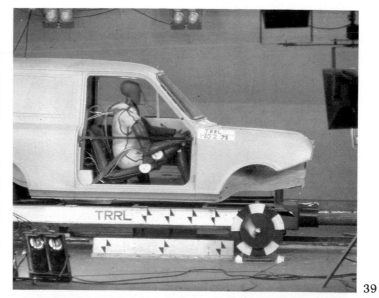

39

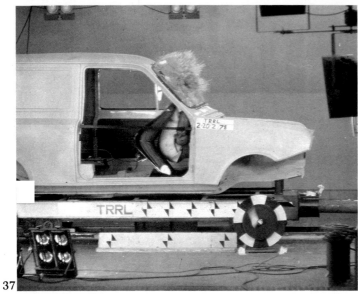

37

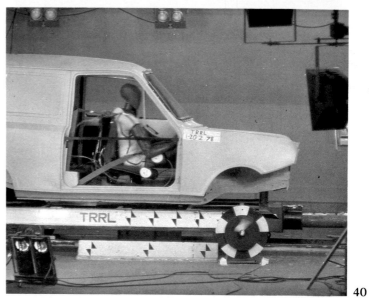

40

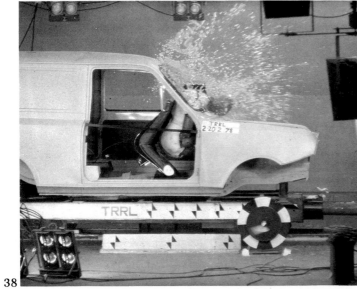

38

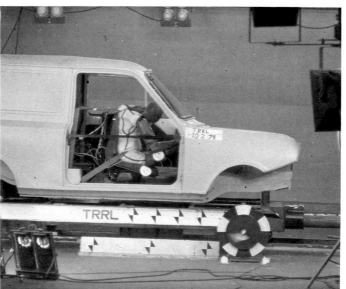

41

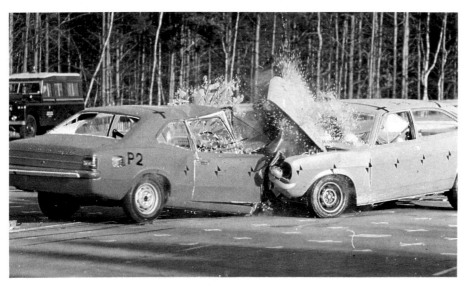

36-42 Clunk click
The macabre consequences of failing
to use safety-belts are graphically
demonstrated (*far left*) in two series of
photographs of a car being rapidly
decelerated in the laboratory (in the
right-hand series the driver is wearing
a belt). The pictures have been
enlarged from frames of a high-speed
cine film. The photograph immediately
on the left is of an 'accident' staged at
the Transport and Road Research
Laboratory, Crowthorne, Berks. All
the photographs were obtained by
using high shutter speeds rather than
flash equipment.

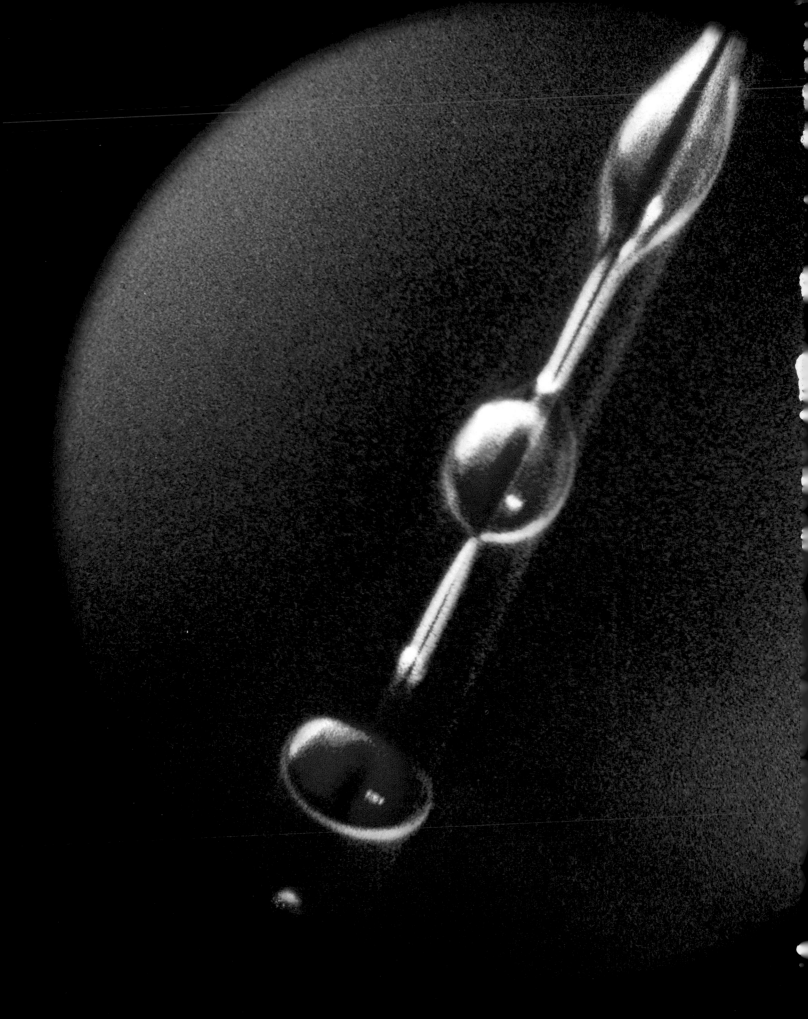

2 Liquid

43 Torn droplet
In micro-encapsulation techniques, used for slow-release drugs, minute amounts of the drug are contained in the centre of many small spherical capsules. These are gradually released at varying rates, controlled by the composition of the capsule walls.

In manufacture, a jet of liquid material is forced through a nozzle surrounded by a well which holds the capsule material, also in liquid form. The jet carries this material along as a sheath until an electrostatic field tears a droplet from it. The action was frozen by a 1/6000 second flash, and is enlarged here over five hundred times.

Opposite
44 Iridescent bubble
A drop of alcohol has just landed on the top of a bubble. The colours are produced as a result of interference taking place within the bubble's surface membrane.

The first person to investigate the behaviour of splashing liquids was Professor A. M. Worthington of the Royal Naval Engineering College, Devonport, England. He used spark photography to help him in his investigations, and in 1908 he published *A Study of Splashes*. In it he expressed his wish to share 'some of the delight that I have myself felt, in contemplating the exquisite forms that the camera has revealed, and in watching the progress of a multitude of events, compressed indeed within the limits of a few hundredths of a second, but none the less orderly and inevitable'. His research led him to obtain much valuable experimental data about the behaviour and changes of form which take place within the surfaces of liquids.

Two principles of physics should be borne in mind when looking at photographs of drops and splashes. First, surface tension is the main factor affecting the behaviour of liquids: the molecules on the surface act rather like a stretched membrane which is always trying to contract and reduce its area. Secondly, a column of liquid is unstable beyond a certain length, and tends to break down into drops. Surface tension affects the formation of these drops, separating each one by a 'squeezing' action and forming narrow necks of liquid, which sometimes break up into smaller drops.

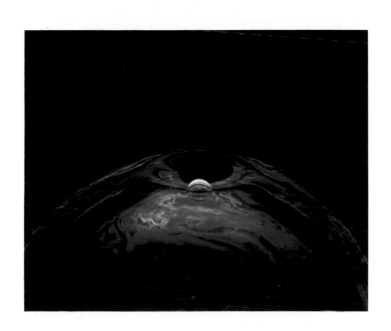

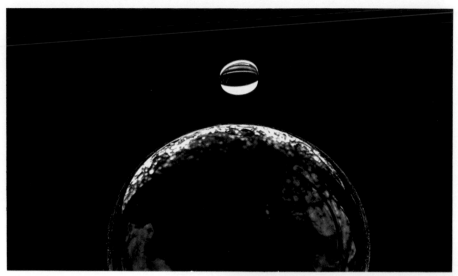

45

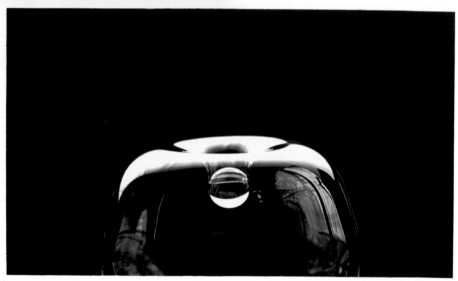

46

45-49 Vanishing bubble
A soap bubble bursts far more rapidly than a balloon, the walls of the bubble disintegrating into minute fragments within a millisecond or so. In pl.45, a drop of water is falling on to the bubble; as the drop hits the highly elastic membrane (pl.46), it drastically distorts the shape before the bubble is actually penetrated. In pls.47 and 48 the bubble has burst, the walls collapsing into thin fragmented fingers. All that remains in the final picture is a cloud of microscopic particles, still outlining the bubble's original shape—even signs of the invagination can be discerned.

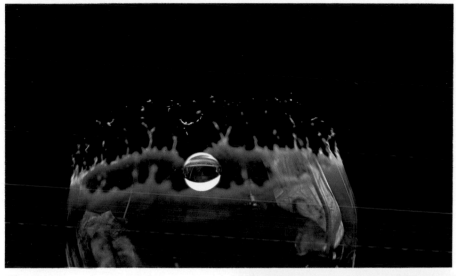

47

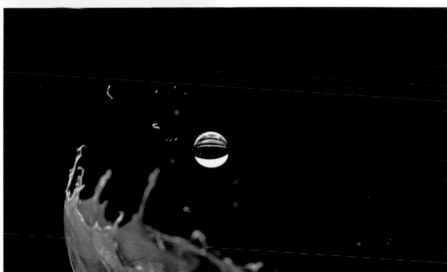

48

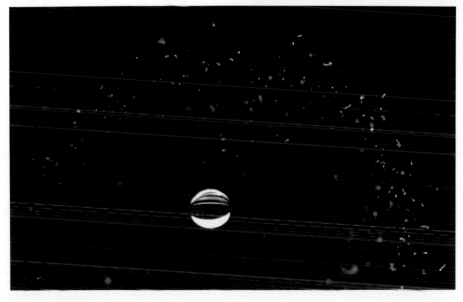

49

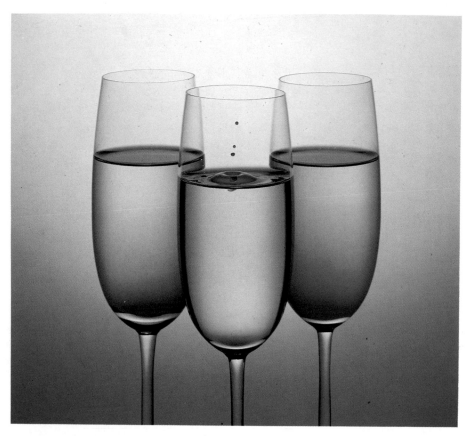

50,51 Making Kir
The object of this advertising photograph was to show *cassis* (blackcurrant liqueur) dropping into white wine to make *Kir*. As the actual drops were so small in relation to the whole picture, a very high-speed flash was not really necessary to stop the movement — the flash duration was approximately 1/1000 second.

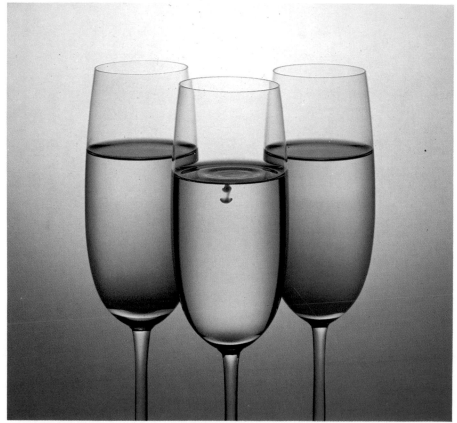

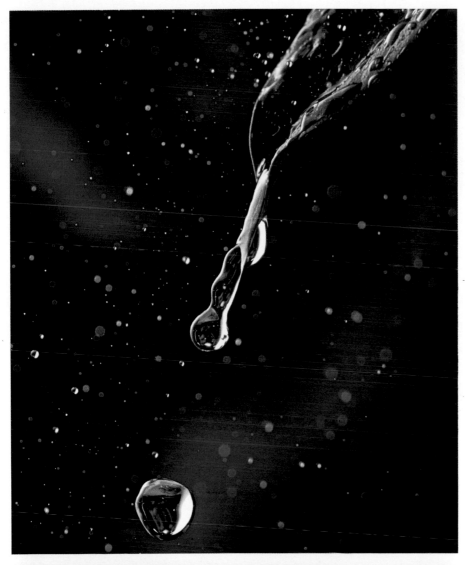

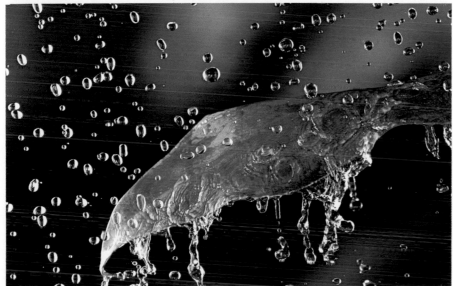

52,53 Raindrops
The wide variety of raindrop shapes is evident in these two pictures, taken at 1/25,000 second. Surface tension generally keeps raindrops more or less spherical, but the pull of gravity, air friction, or collisions with objects and other drops causes distortion.

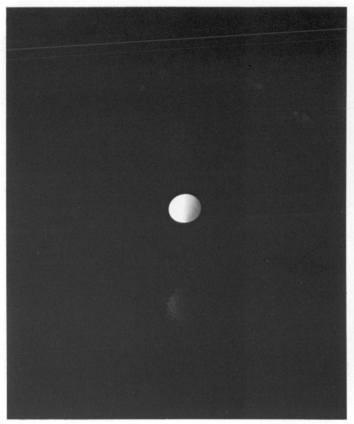

54

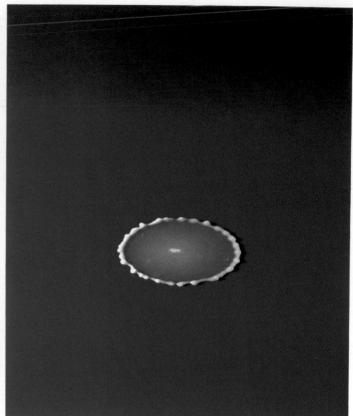

55

56

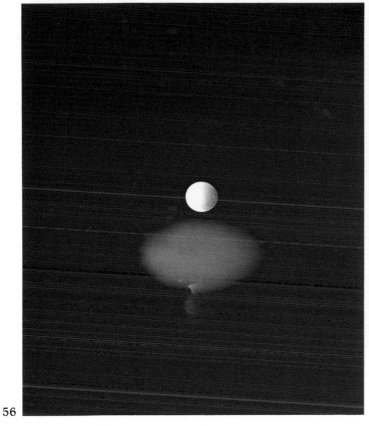

56

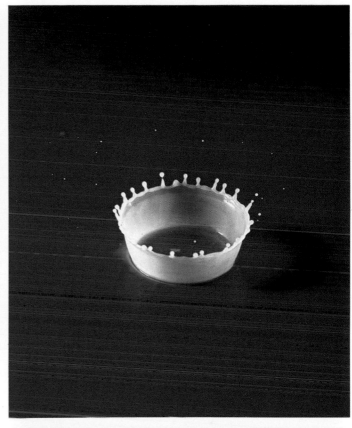

57

54-58 Spilt milk

A drop of milk is caught just before it hits the empty saucer (pl.54). After making contact with the saucer (pl.55) the liquid spreads out sideways in all directions.

In pl.56 a second milk drop is about to land on top of the first one. The second drop, instead of moving out in contact with the saucer, is forced up vertically by resistance within the first drop (pl.57). As the hollow column begins to lose its momentum, surface tension causes the top of the ring to disintegrate into the characteristic coronet shape. As the walls collapse, thin fingers of milk begin to form, which in turn break up into smaller drops (pl.58).

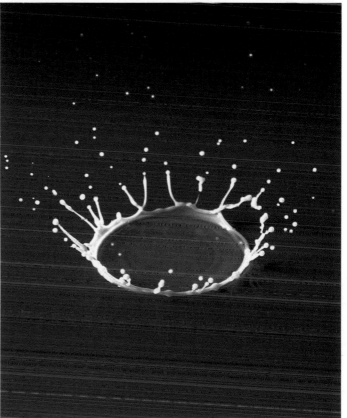

58

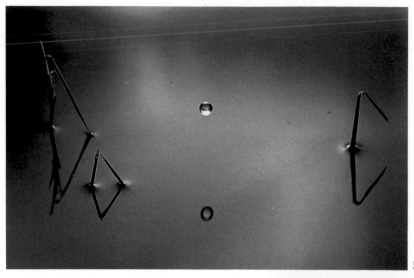

59

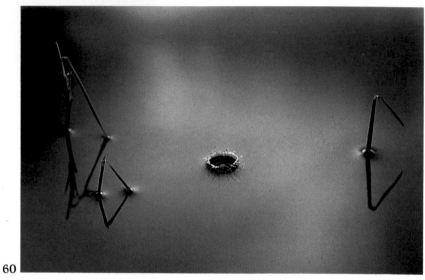

60

59-63 The first drop of rain
It is impossible to appreciate the full beauty of a drop of rain
and its effect, until the drop is isolated in time and space by
the camera.

Overleaf
64-71 Raindrop and puddle
When a drop of rain falls into relatively deep water,
the resultant behaviour of the mingling liquids
is entrancingly different from that when the drop falls into
shallow film (as with the milk drop, pls.54-58).
Although a coronet is formed, it is a much feebler affair
(pl.65), as its walls soon collapse to form an expanding and
deepening crater (pl.67).
 Eventually, after a delay of several milliseconds
a water spout emerges which rises up to a point when it
becomes unstable and due to the effect of surface
tension breaks its top portion into separate drops (pl.68).
Finally the spout collapses to leave a ripple on the
water's surface.

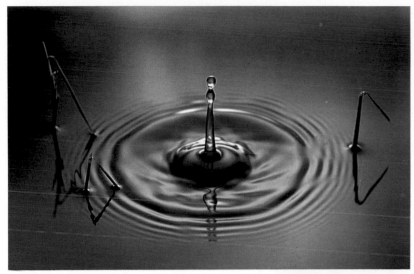

61

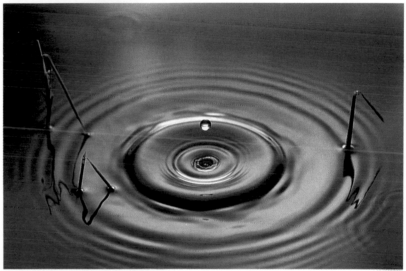

62

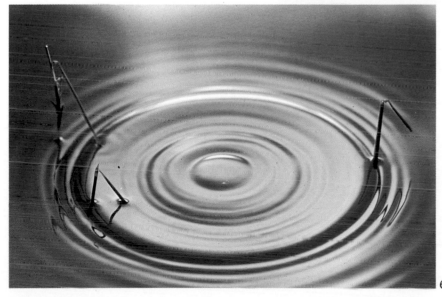

63

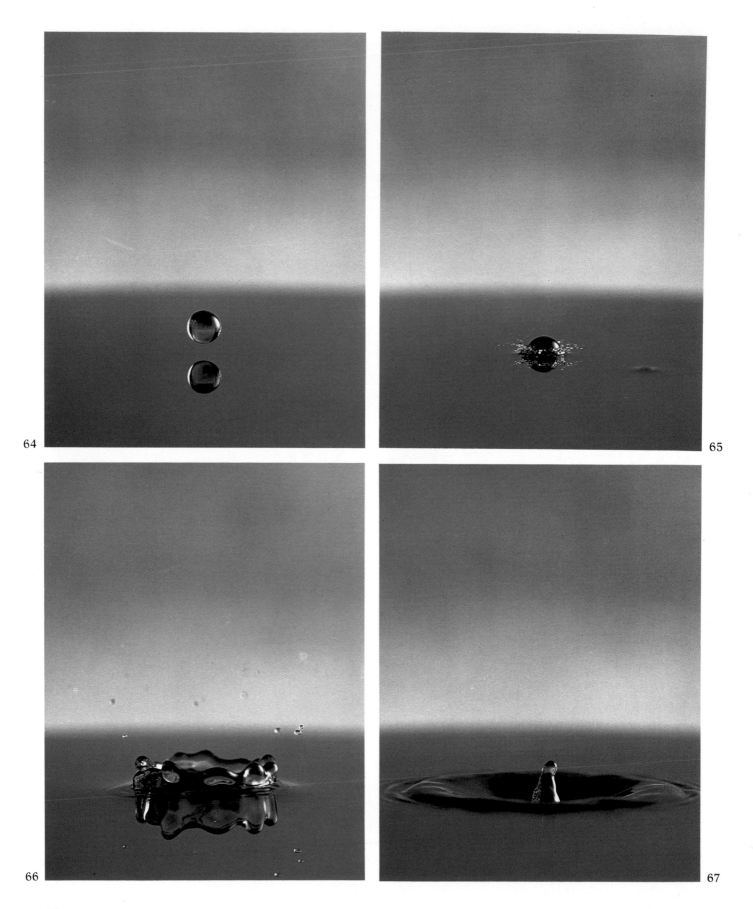

64

65

66

67

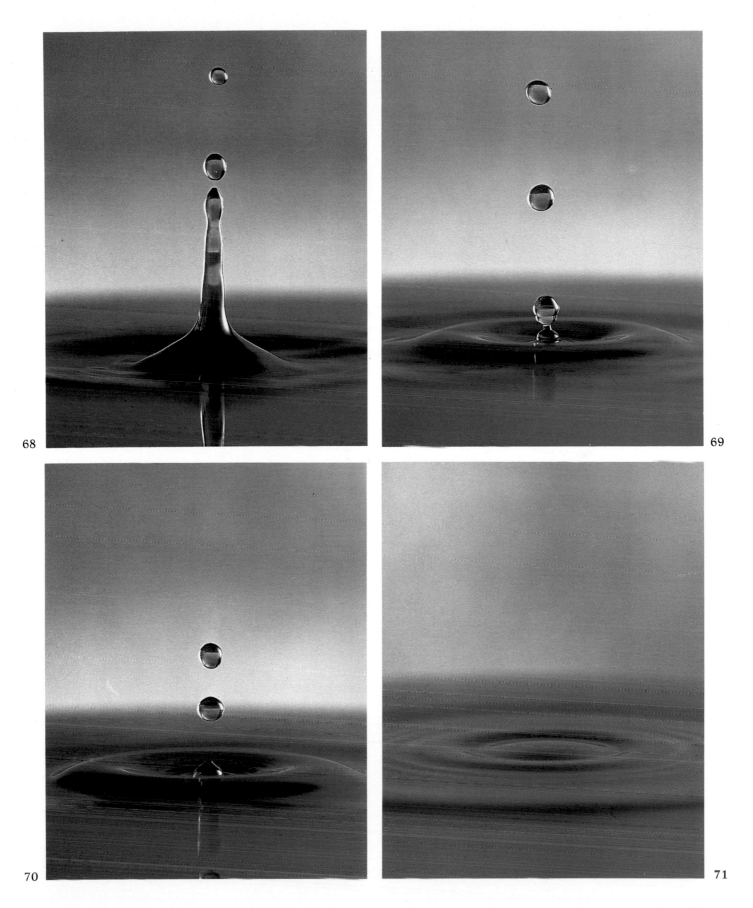

68

69

70

71

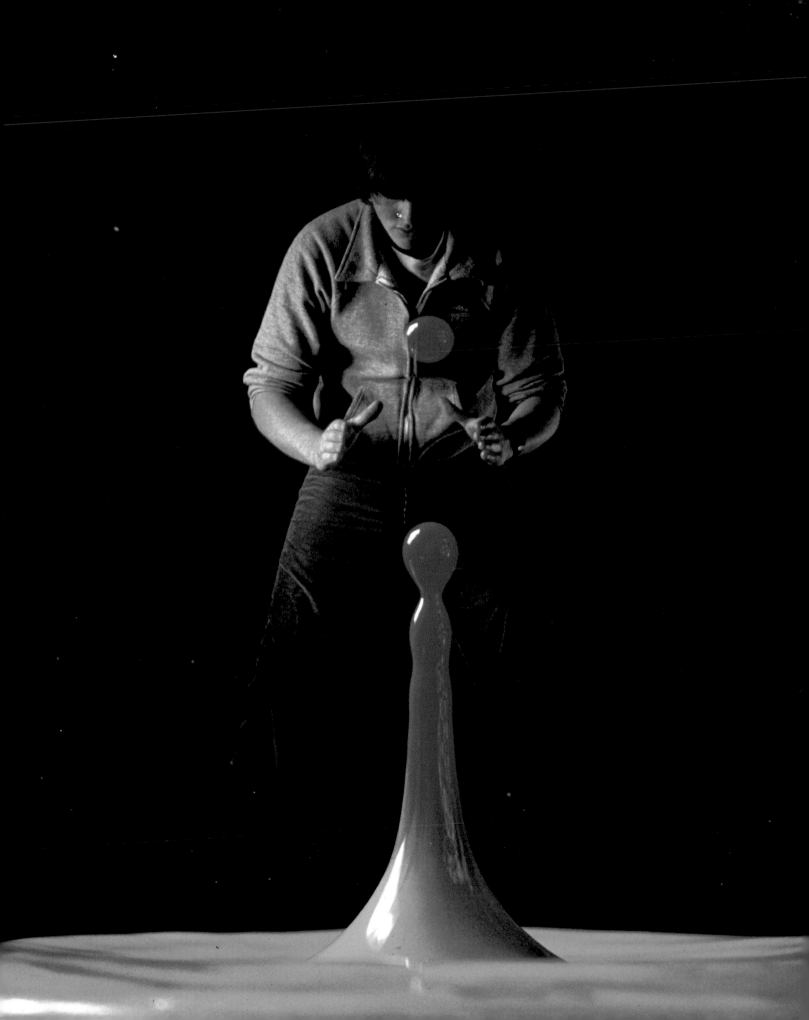

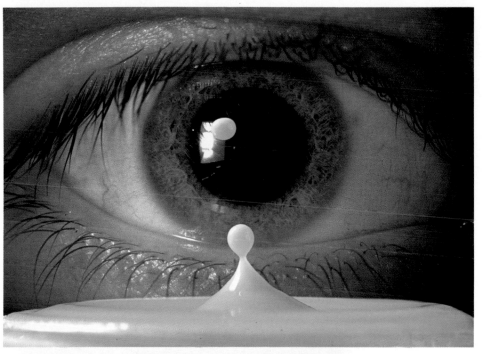

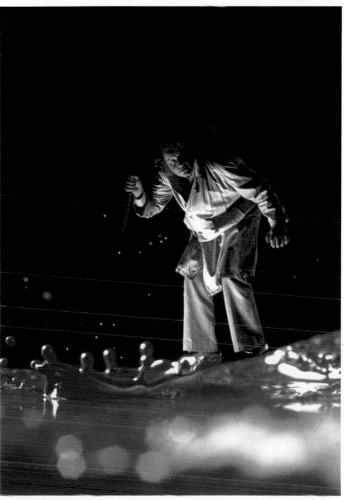

72-74 Aerial imagery
Weird and striking images can be made by employing a relatively new photographic technique known as aerial imagery. It achieves the apparently impossible by combining in sharp focus subjects in both the foreground and the background which cannot normally be focused upon simultaneously. The dubious-looking character in pl.74, for example, is in fact some fifteen feet (4.5m) behind the 'blood'. The system can also be used to distort the relative sizes of objects in a scene, so that a person can be made to appear as small as a drop of water—as in pl.72.

The photographic hardware necessary to achieve all this is somewhat complicated, involving a large optical bench with several sets of strategically positioned lenses and condensers as well as the camera itself.

The three photographs shown here were taken to demonstrate the versatility of this special-effects technique, and were exposed in conjunction with high-speed flash—high-speed being used to arrest the action in the foreground, and conventional studio flash for illuminating the background.

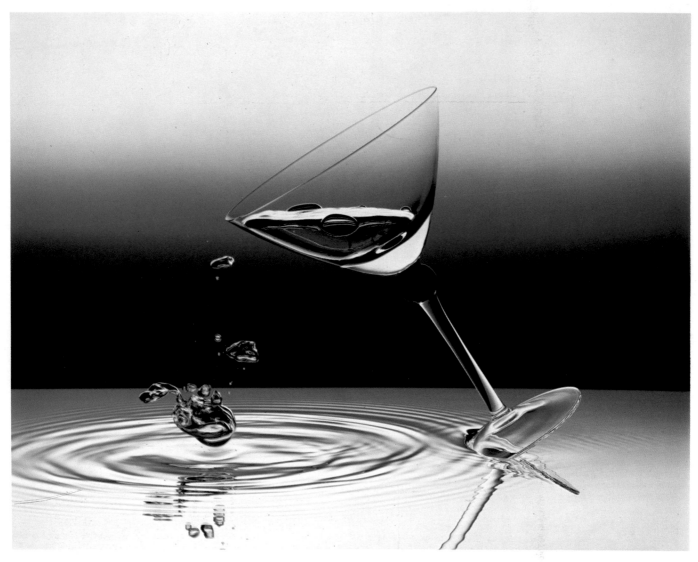

75 Bubbles not drops

This picture is not what it appears. What look like drops of liquid falling out of a glass, are in fact bubbles of air rising up *from* a glass. To obtain the photograph the glass was inverted in a tank of water, so that a pocket of air was retained in the bottom. As the glass was tilted, the bubbles were released and rose to the surface. Inverting the picture will make the technique more obvious.

Opposite
76 Frozen water

A 1/50,000-second flash transforms a jet of tap-water into a chunk of 'ice'. Note that the water is streamlined as it leaves the tap, but quickly becomes turbulent.

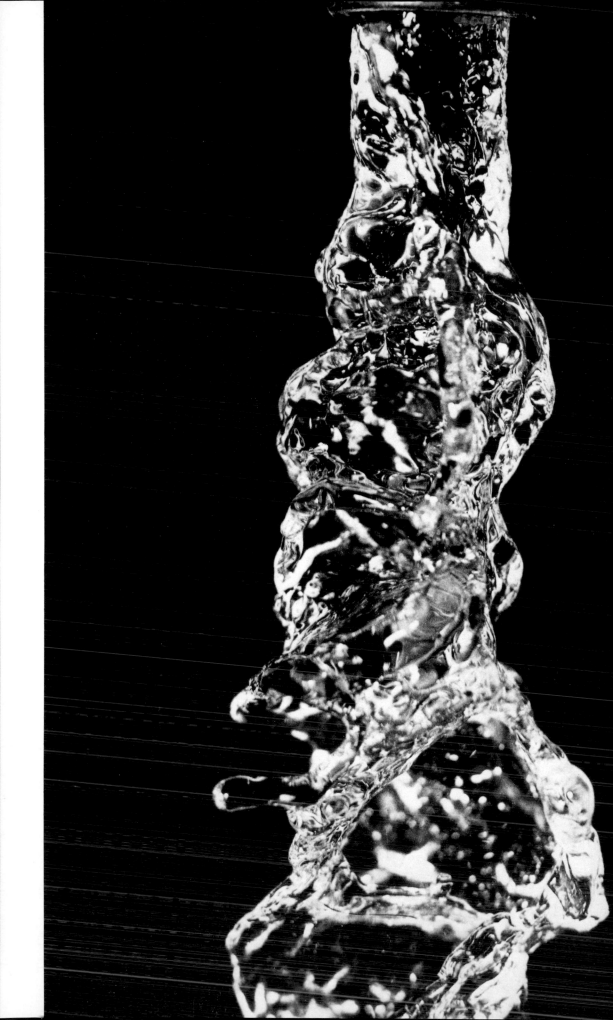

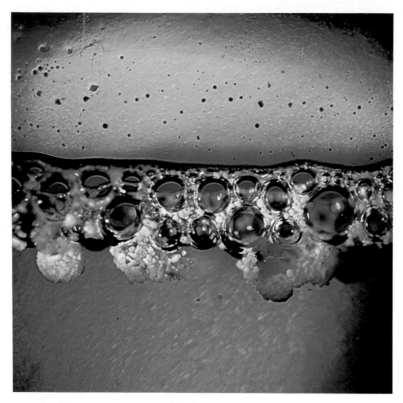

Detergent bubbles
77 Below the surface of a warm bubbling detergent solution are partly dissolved animal-fat globules, white and golden, before the detergent action finally converts the fats into solution. The actual process of tearing apart the fat particles, frozen at about 1/2000 second by the camera, is clearly visible below the bubble layer in the centre.

78 When a soap or detergent bubble is formed, a whirlpool of activity takes place within the bubble membrane. Both gravity and molecular forces are responsible for this strange behaviour, causing, in the early stages, droplets to drift across the skin, and, later, a display of ever-changing colours due to interference. This photograph was illuminated with a tungsten halogen lamp, and exposed at 1/1000 second to arrest the flow of the liquid.

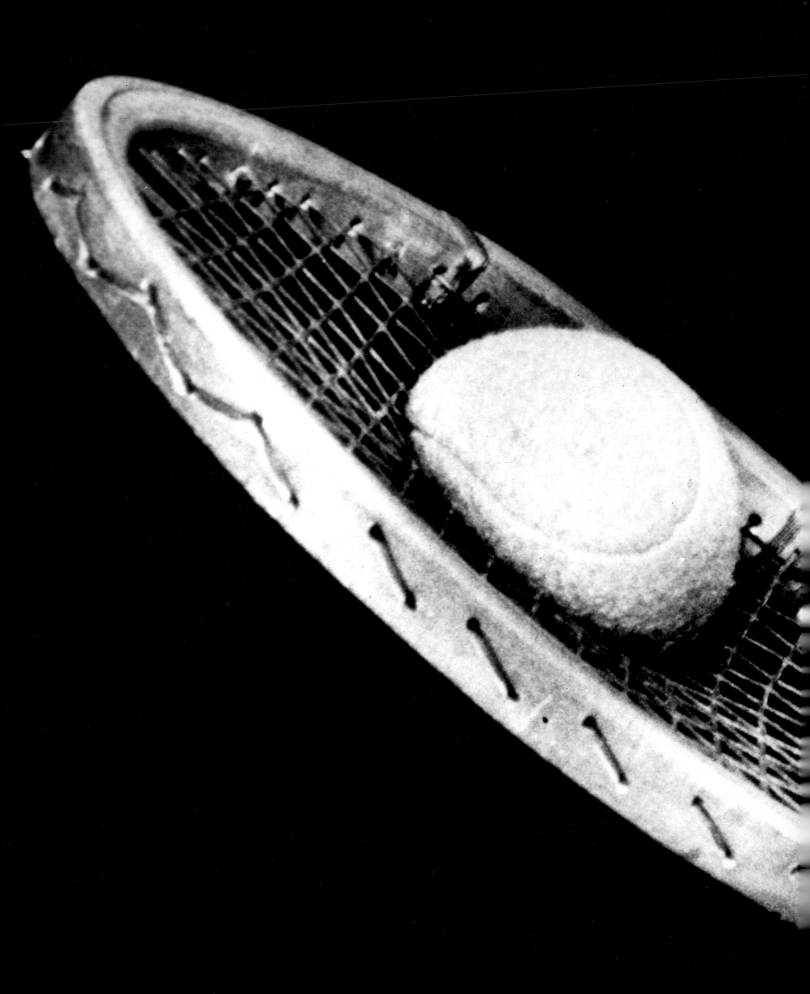

3 Sport

79 Ball meets racquet
As the tennis ball makes impact on the strings of the
racquet, the ball is flattened and the strings indented.
This photograph and many similar ones were taken by
both single-flash and multiple flash (stroboscopic)
photography during the 1930s for investigating the
behaviour of sports equipment in action.

Both still and motion photography have proved invaluable in studying the action of human bodies in motion, and stroboscopic photography particularly has been useful in the analysis of technique.

The experimental work of Michael Faraday in the mid-nineteenth century inspired two men independently, Plateau of Ghent and Stampfer of Vienna, to invent the first stroboscope — a simple revolving slotted disc used for observing rapidly moving objects. Some hundred years later, in the 1930s, the first flashing-light stroboscope was developed by Harold Edgerton. It was not long before he designed an instrument that produced a light bright enough to illuminate large areas for photographic purposes, and which could be accurately controlled and timed. Although he devised the stroboscope as a tool to solve engineering problems, many of the photographs he took were very striking, and have since become classics.

Sports photography is one of the few areas of 'high-speed photography' (action photography is a more apt description) which can be tackled by anyone with a suitable camera. A number of the photographs in this section have been exposed by available light with a 35mm camera, set at shutter speeds around the 1/250 to 1/1000 second mark. In this way it is possible to obtain exciting records capturing split-second movements which the eye usually misses or sees as fleeting blurs. Success in this branch of photography depends on the right blend of bright light, fast film, high shutter speeds, wide apertures and split-second timing.

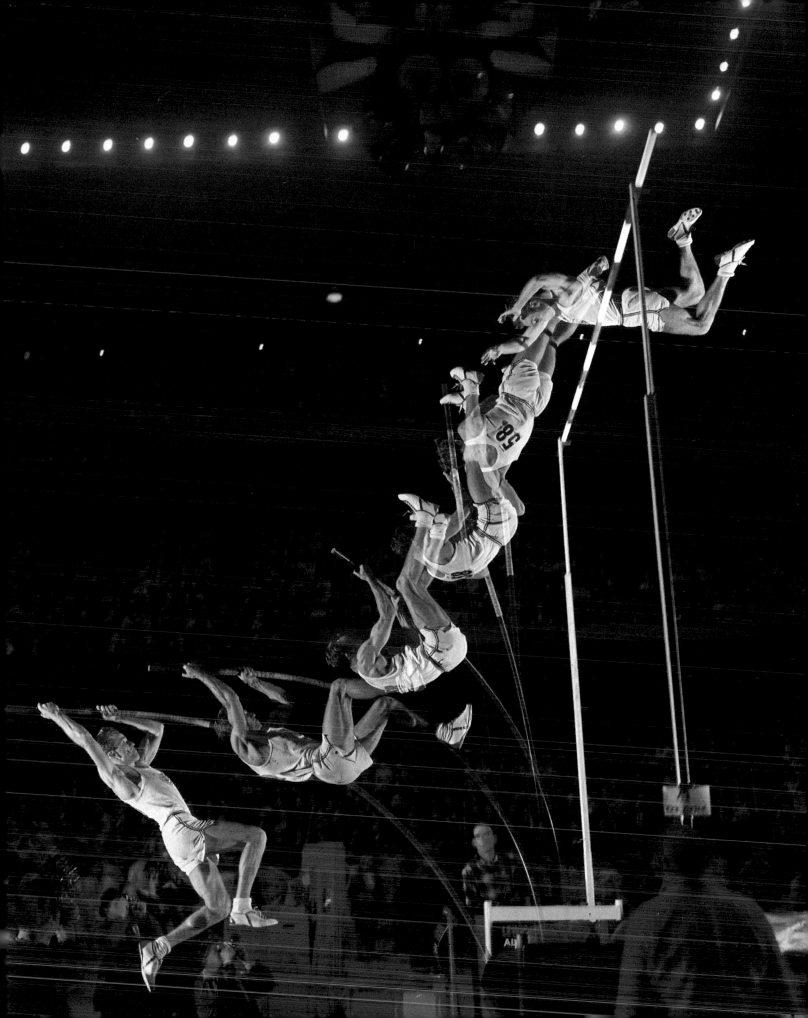

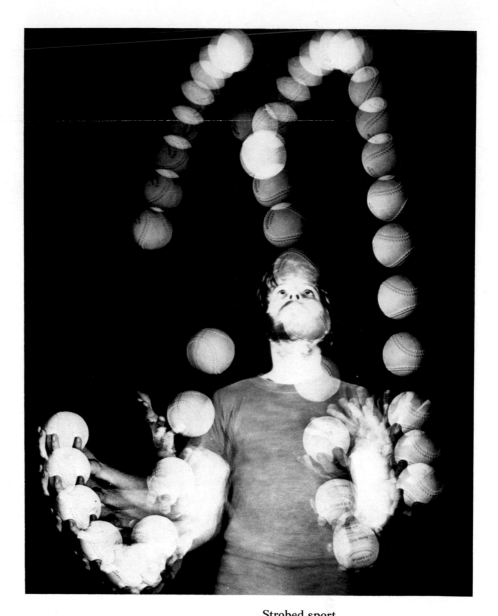

Strobed sport
81, 82 Both the juggler and the skipper here were photographed with flashing-light stroboscopes. For the picture of the juggler, Jerome King, ten strobe flashes were taken 1/30 second apart.

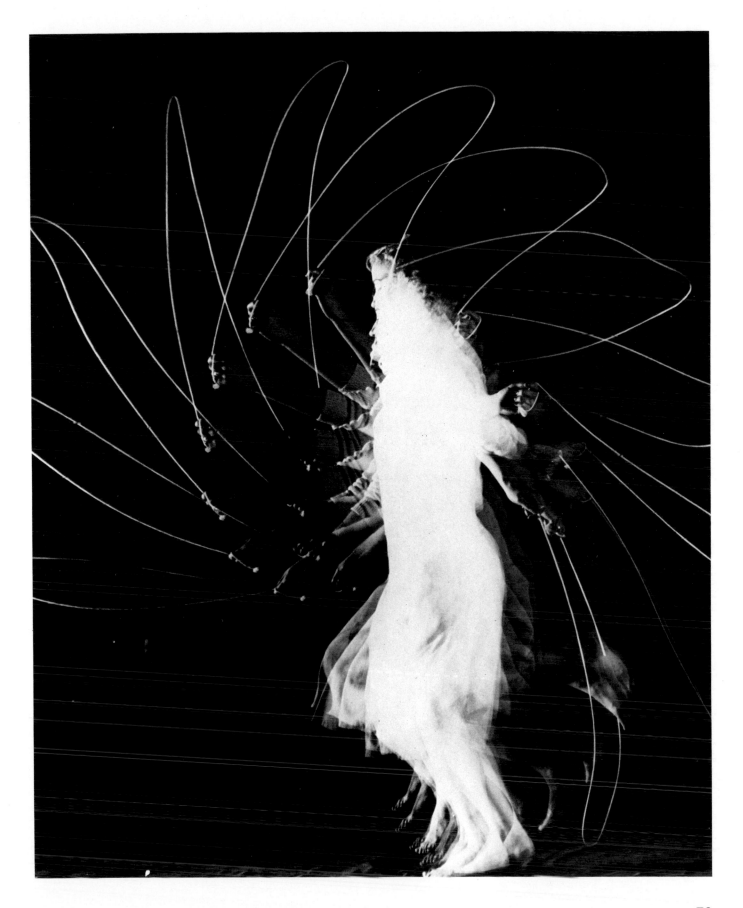

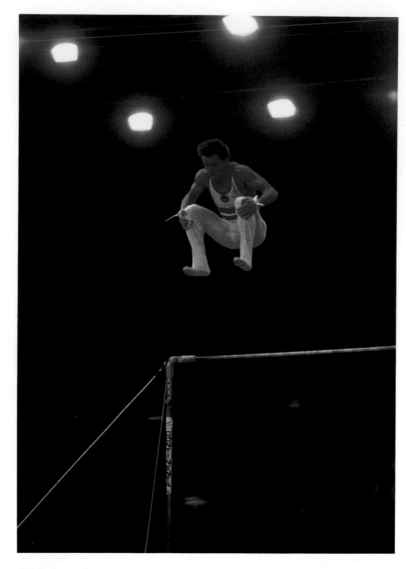

83 Pole-vaulter
This photograph was taken with a 35mm camera set at a shutter
speed of about 1/1000 second.

Opposite
84 Gymnast
The grace of human movement is beautifully illustrated in this
delicate multi-image photographic study. Conventional studio flash
(speed around 1/500 second) was used for illumination.
Approximately twelve flash units, linked by a delay unit, were made
to fire consecutively over one second, the time needed to cover the
gymnast's movement.

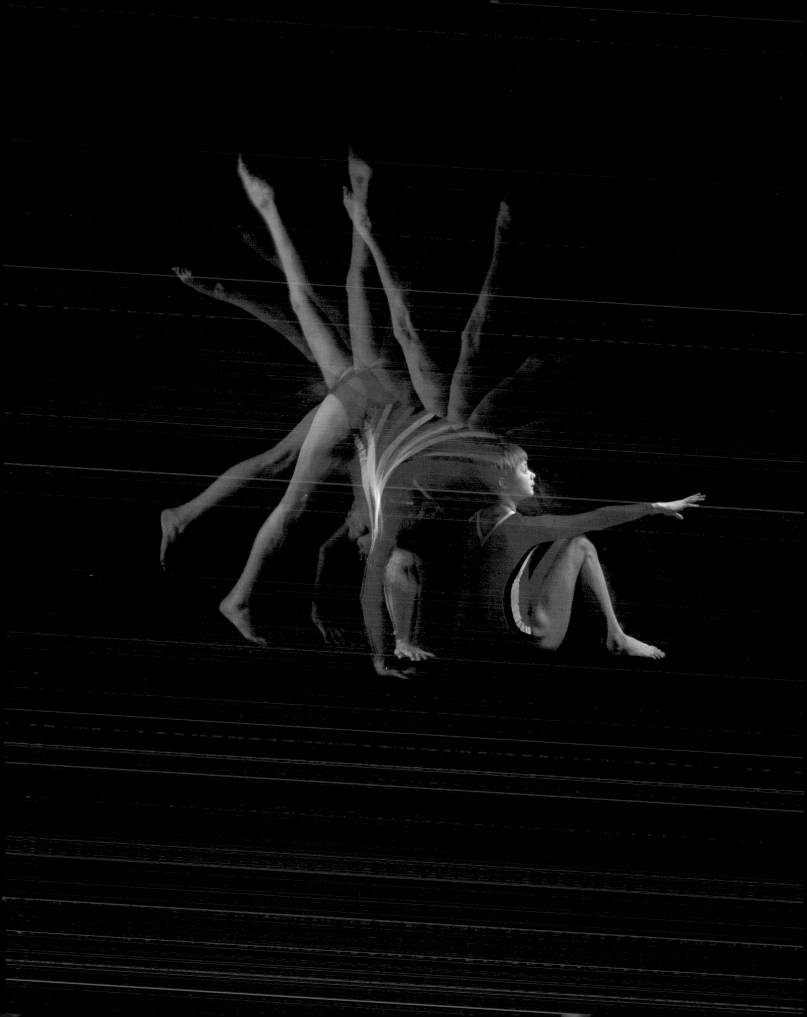

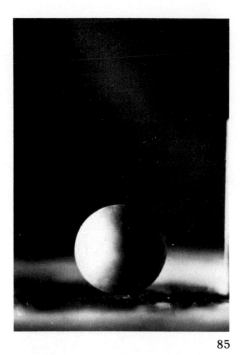

85

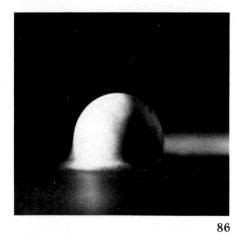

86

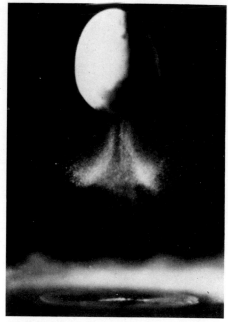

88

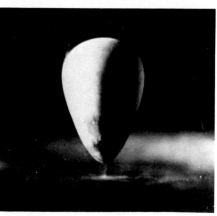

89

Distortion

85-90 When a soft rubber ball bounces, its shape constantly changes. After the initial impact it flattens, then before leaving the ground it becomes pear-shaped. As it rises upwards, complete with the dust cloud which is sucked up with it from the floor, the ball pulsates like a primitive life-form, swelling first in one direction and then the other.

Opposite
91 During the brief instant when the boot makes contact with the ball, the ball is dented by at least half its diameter (the ball is inflated to its normal pressure). Once the ball is in the air, it pulsates in and out until it recovers its normal contours. Note the small cloud of suspended dust at the top of the ball.

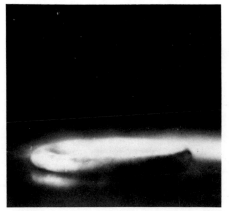

87

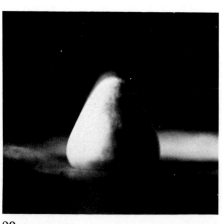

90

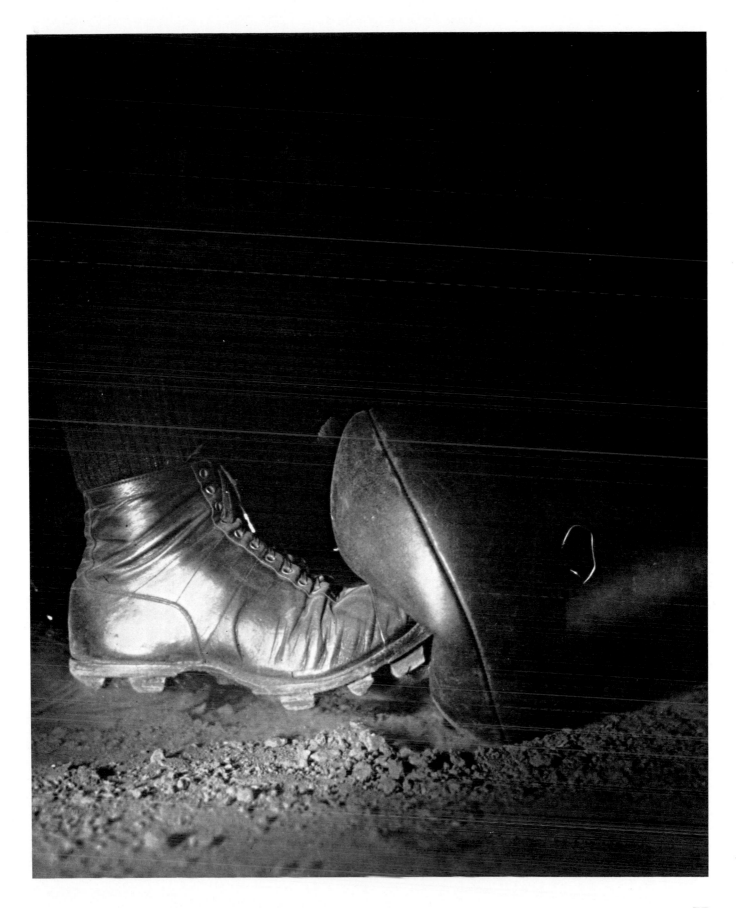

92 Skateboarder
Airborne skateboarder 'off the wall' at
the National skatepark of El Cajon,
California.

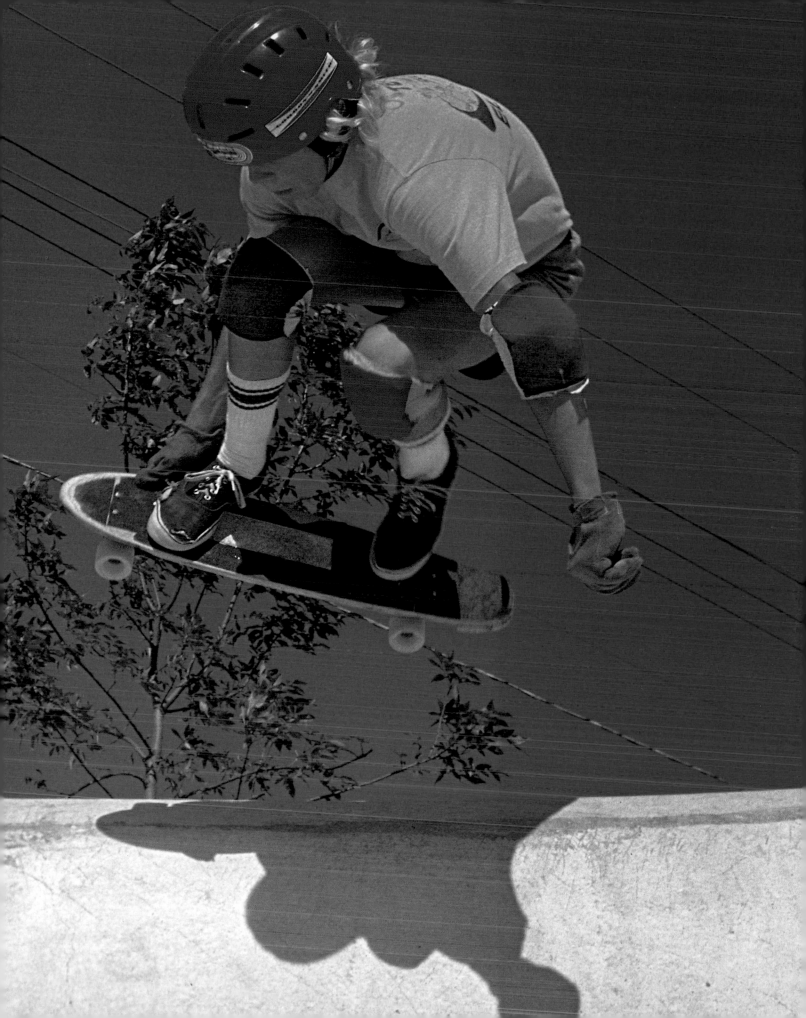

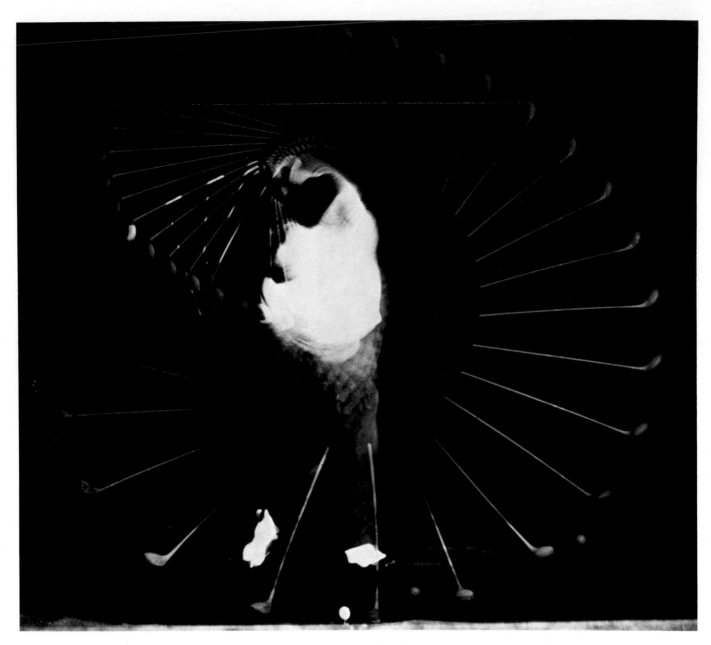

Golf strokes

93 Edgerton's extensive strobe photography of golf strokes put an end to many arguments. Among other things he demonstrated that the club and ball remain in contact for only 6/1000 second, during which time they travel together for about one third of an inch. Note the bend in the shaft after the ball has been hit. This picture of the golfer Dennis Shorte was taken in 1938.

Opposite
94 After a golf-ball has been struck by the club, it pulsates, swelling and shrinking along its horizontal axis.

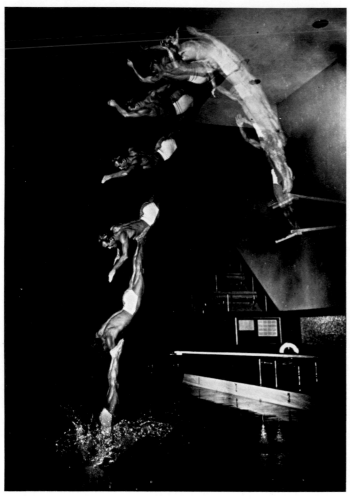

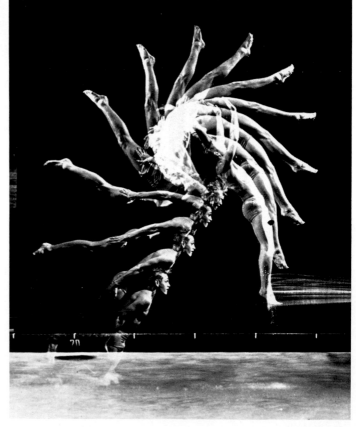

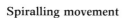

Spiralling movement
95 A stroboscopic photograph of a front dive with a twist, taken at the M.I.T. pool in 1941.

96 A back dive, taken at a rate of thirty flashes per second for half a second.

Opposite
97 The dancer Gus Solomon, photographed with sixteen strobe flashes, in 1960.

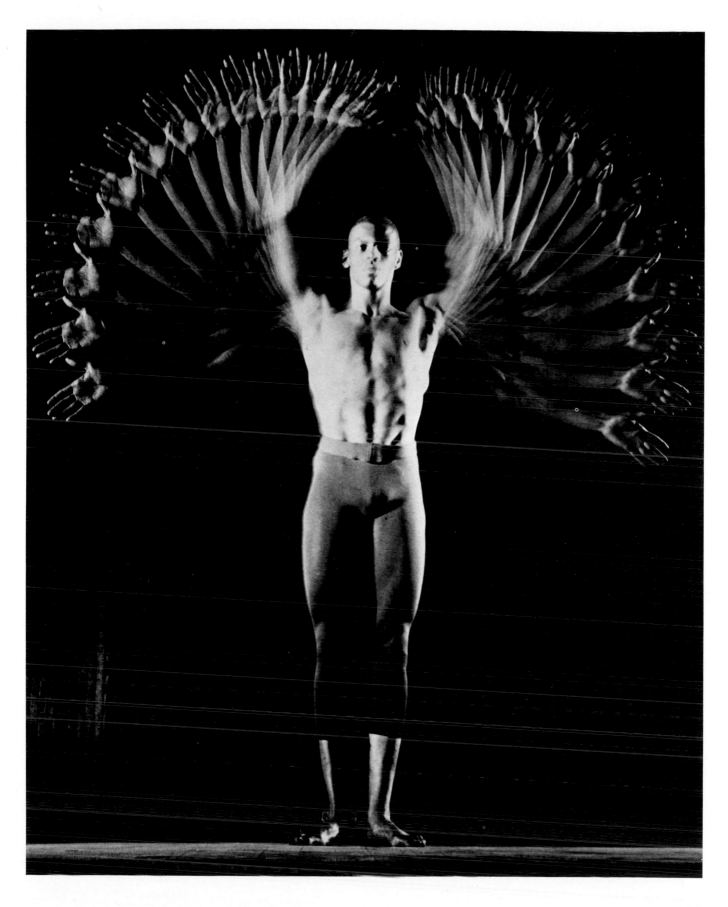

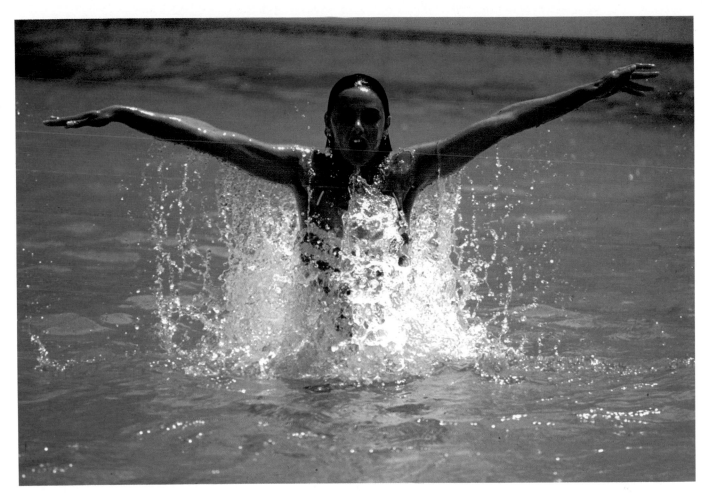

98, 99 High jumps
These two photographs were taken with 35mm cameras
set at shutter speeds of about 1/1000 second.

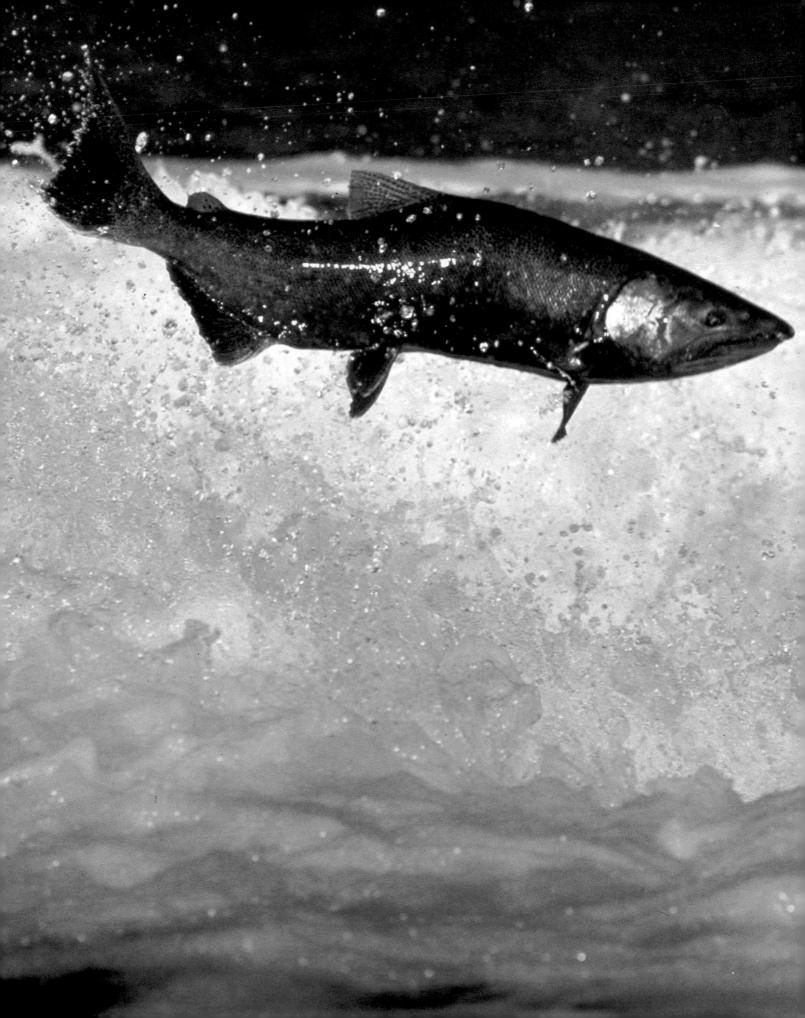

4 The Natural World

100 Leaping salmon
When moving upstream to their spawning beds, after a journey of about 2,000 miles from the Sargasso Sea, salmon show extraordinary strength and agility, leaping weirs and making their way up seemingly impossible waterfalls. The shutter speed used to capture this fleeting movement would have been in the order of 1/1000 second.

Man has always been curious to know precisely what happens when an animal moves at speed. Muybridge in the USA and Marey in France were the first to use photography to analyse animal movement, but the fine details of fast-moving subjects remained tantalizingly out of reach. (For a variety of reasons the high-speed spark was wholly unsuitable for photographing living creatures.)

It was not until electronic flash became available that the full potential of the camera's ability to freeze living motion was realized. First the grace of birds in flight, and later the stunning aerial antics of flying insects, leaping frogs, striking snakes, and the spectacular nocturnal on-the-wing hunting techniques of bats were all revealed with utter clarity, teaching us us much about animal locomotion, feeding techniques and even aerodynamics.

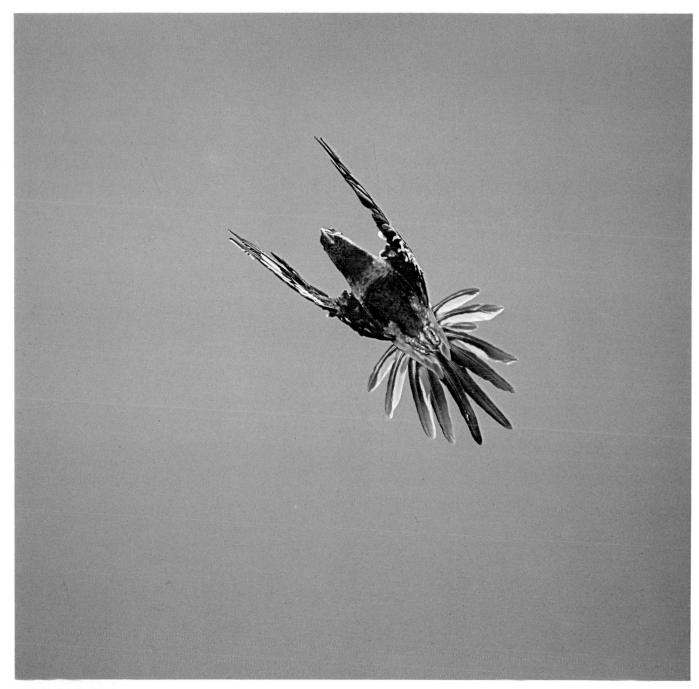

101 Rainbow lorikeet
The rainbow lorikeet, found in the East Indies and Australia,
is one of the world's most brilliantly coloured birds, whose
plumage contains all the main spectral colours. The bird was
photographed in captivity and the picture shows an
unconventional view from beneath, with the wings extended
fully forwards.

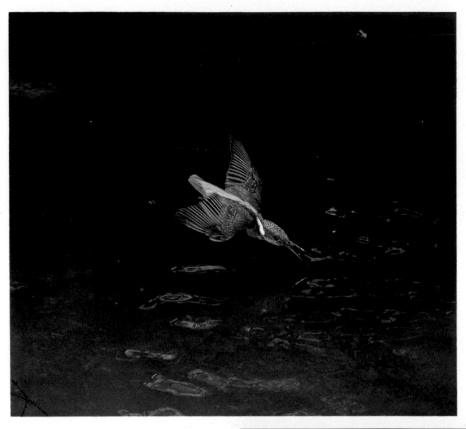

102-104 Diving kingfisher
Having just fed its young in its nest tunnelled out of the bank of a stream, a kingfisher dives headlong into a shallow pool to clean itself. Note that, just before hitting the water (pl.102), the bird protects its eyes by closing its nictating membrane. A moment later it rockets out with a dramatic splash (pl.104) and then flies upstream to continue its fishing activities. The photographs were taken with a 1/5000 second flash unit, triggered by a light-beam.

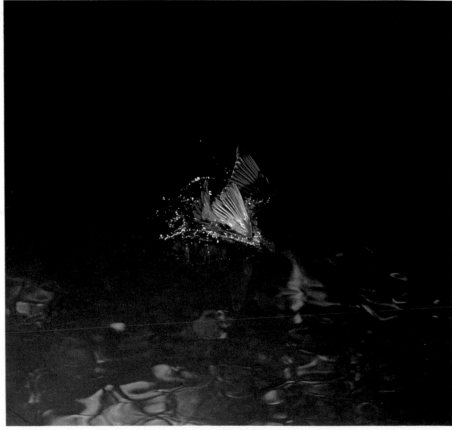

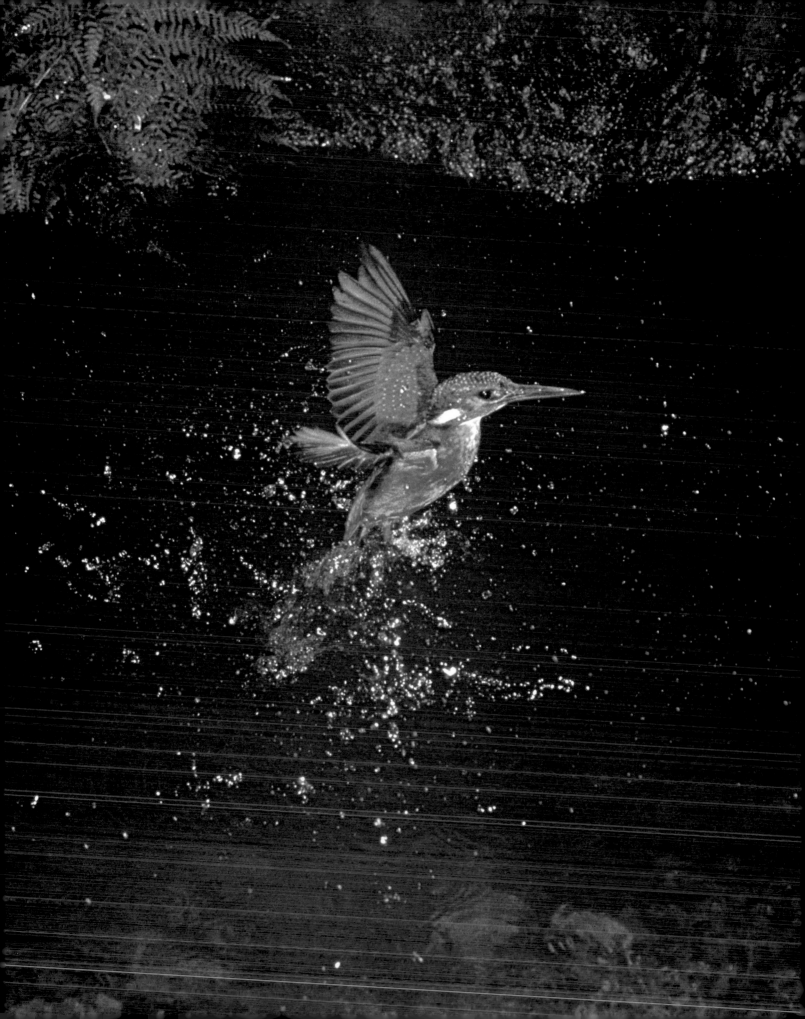

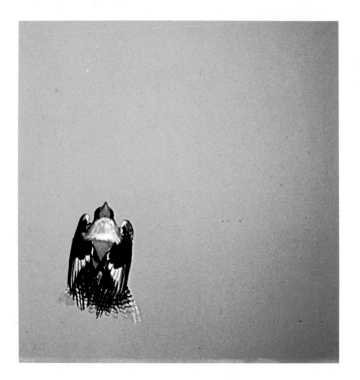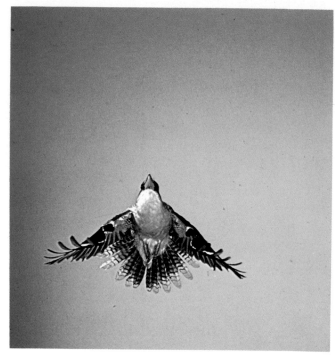

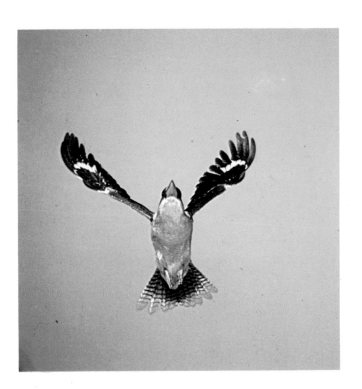
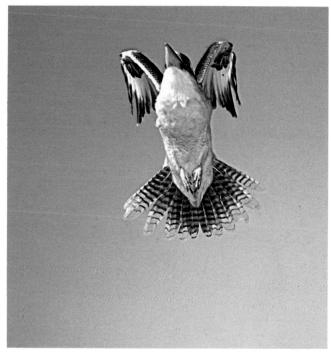

105-108 Kookaburra

This series of pictures shows some of the attitudes adopted by a kookaburra as it flies across a studio set. The kookaburra, or laughing jackass, lives in the Australian forests and is the largest member of the kingfisher family, being about the size of a raven. It owes its name to the disturbing, strangely human laughing cries which it utters when it goes to roost at dusk.

As well as other prey, the kookaburra feeds on snakes which it kills either by dropping them from a height or battering them senseless with its big bill. Occasionally the bird will even raid farmyards for ducklings and baby chicks.

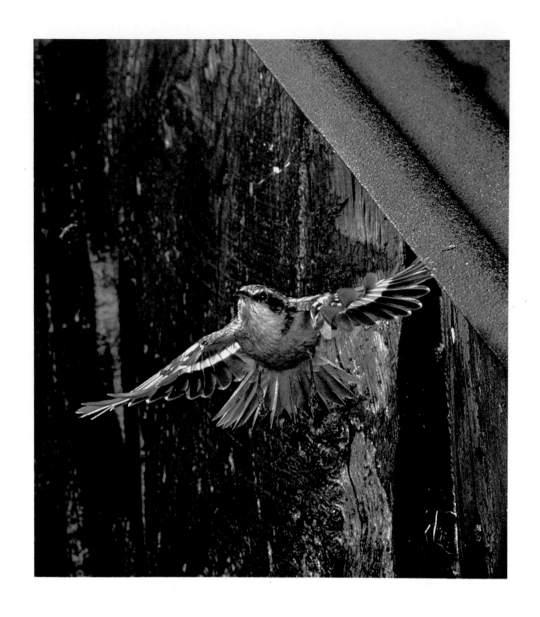

Opposite

109 Tree-creeper

The bird has just taken off from the side of a garden shed.
Its nest and young are safely concealed in a crevice between
two timber planks at the bottom right of the picture. A flash
speed of 1/25,000 second is more than fast enough to arrest
the wing movement of any bird.

Below

110 Swallow at nest

The swallow is one of our faster-flying birds, and to be
certain of stopping its wings under all flying conditions a
flash speed of 1/5000 or 1/10,000 second is needed. This
parent bird is about to hover for a brief instant in order to
feed its ravenously hungry young.

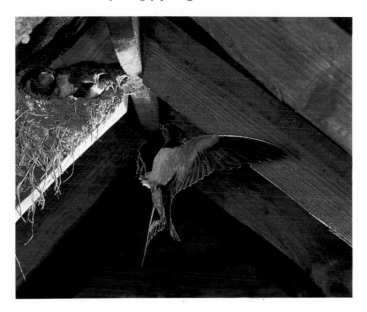

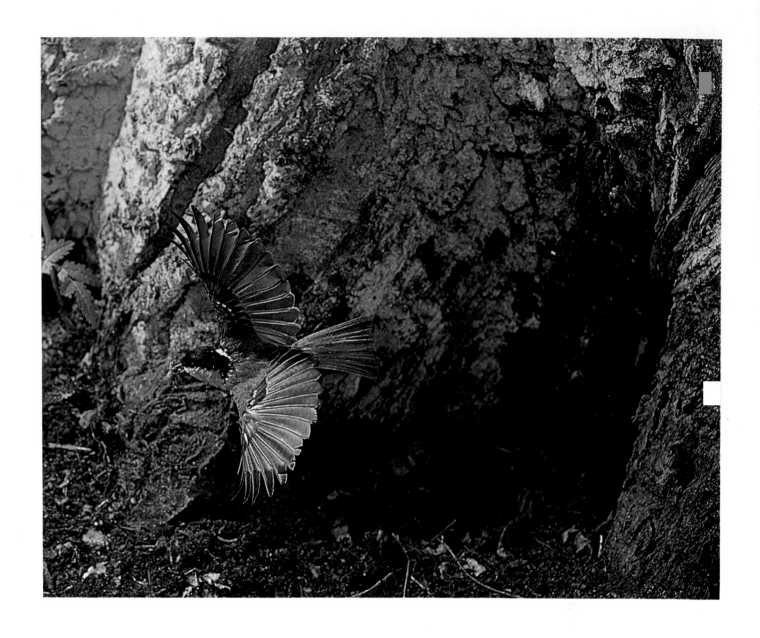

111 Coal tit
Having just fed its young in a nest-hole at the base of an oak tree, this coal tit is flying off to search for more juicy caterpillars.

Opposite
112 Rattlesnake striking
The speed at which snakes strike is exceedingly rapid and dictates the use of short-duration flash to stop all motion. The jaws of snakes are specially hinged, allowing them to open to almost 180°. This is particularly important with venomous species because the fangs curve inwards and need to be plunged vertically into the prey. The snake's windpipe protrudes at the bottom of the mouth, enabling the creature to breathe while swallowing prey whole.

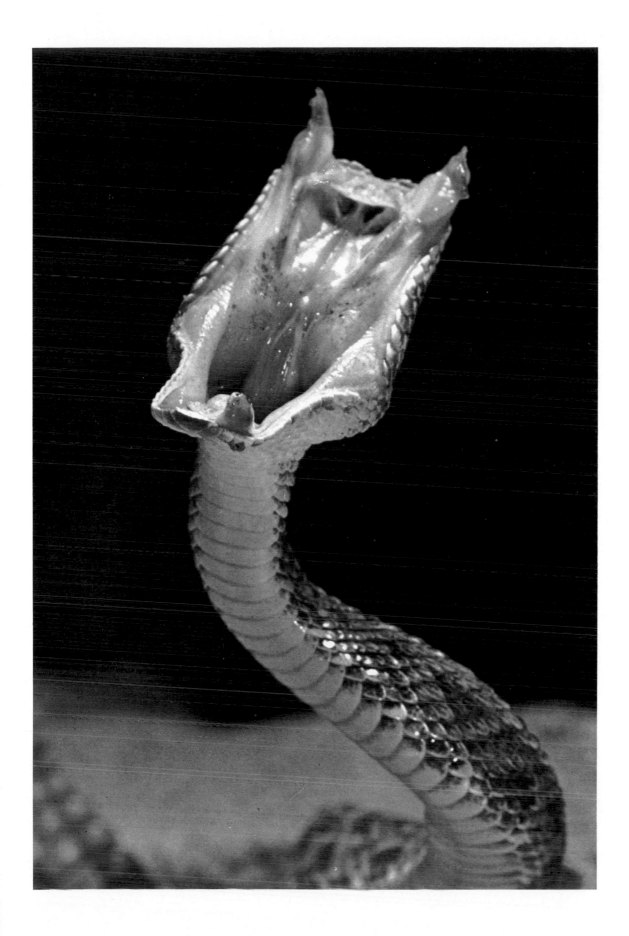

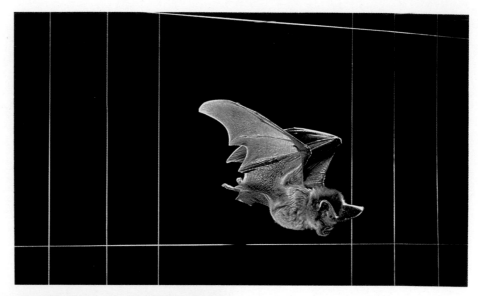

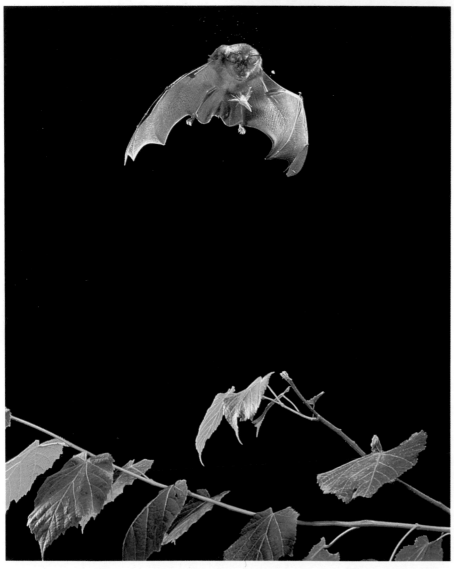

Left
113 Greater horseshoe bat
Among winged vertebrates, the bat's breathtaking flying ability is only matched by that of hummingbirds. Most species of bats are able to hunt in total darkness by means of an echo-location system of amazing accuracy. The horseshoe bat makes use of the Doppler effect, by detecting the minute shift in apparent frequency of the echo resulting from the relative speed and direction of the flying insect. The animal can thus locate the precise position of its prey. Here the bat is caught a split second before ensnaring a moth.

Above and opposite
False vampire
114 High-speed still photography demonstrates the precision of a false vampire's echo-location system. Strands of thin steel wire were strung between two adjacent rooms, and in total darkness the bat always managed to avoid touching them, usually detecting the largest aperture and flying straight through it with wings half folded.

115 The false vampire's extraordinarily sensitive hearing can detect the slightest rustle of potential prey. This bat homed in on the mouse from some thirty feet away, seized the creature by the scruff of the neck and carried it away to a convenient perch.

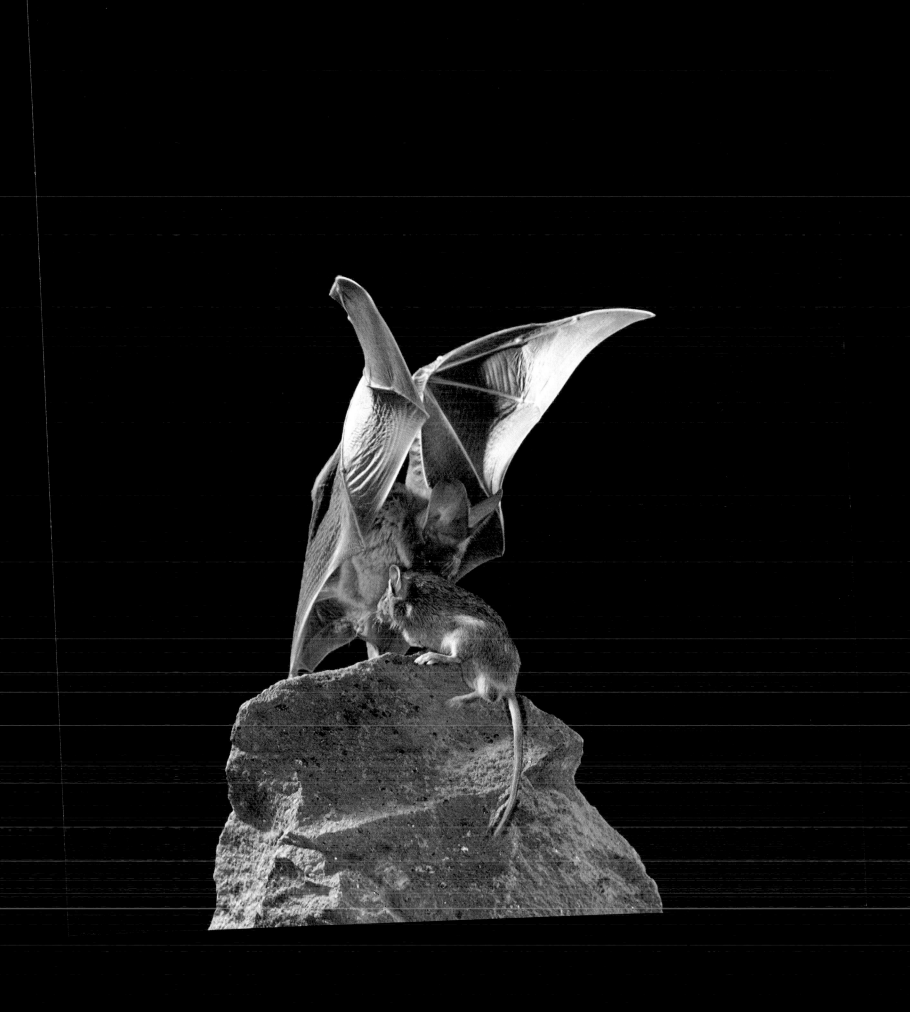

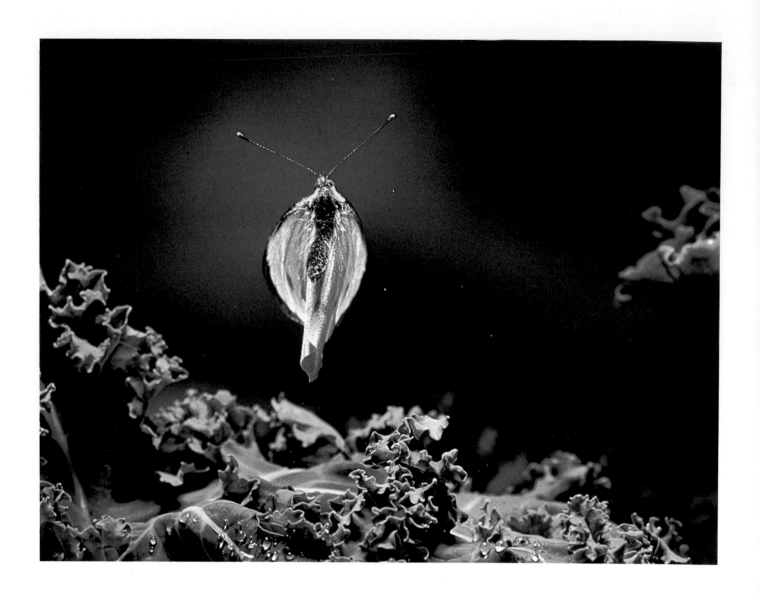

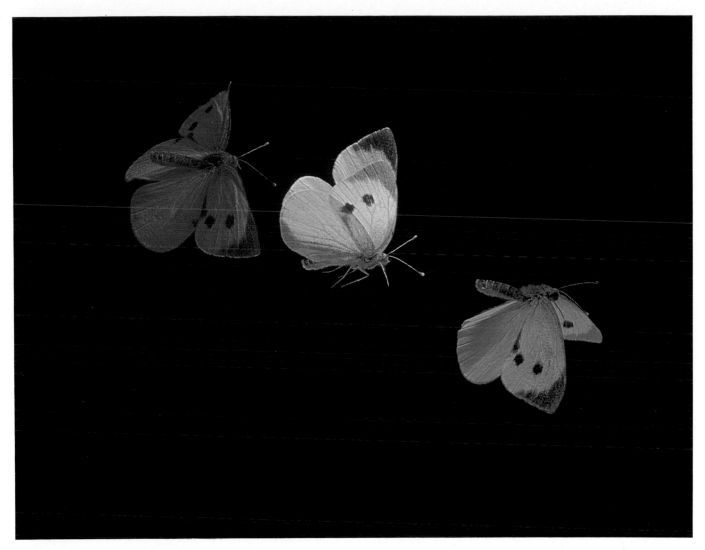

116, 117 Large cabbage white
Two unusual high-speed photographs of the same butterfly.
On the left it has just taken off from a curly kale leaf. The
insect is flying away from the camera, and in its efforts to
gain sufficient aerodynamic lift the wings are folded so far
forward that they are touching.

On the right is an intriguing variation of multiflash
photography, where the images are separated chromatically.
Each of the flash heads was covered by three different
coloured filters, in this instance magenta, yellow and cyan.
The technique has perhaps limited scientific applications
and is best suited to subjects of more or less neutral colour,
but it can help to separate overlapping images.

Overleaf
118 Butterfly taking off
High-speed multiflash photography has revealed some
fascinating insights into insect flight. If a sequence of
flashes is fired with a predetermined interval between
each, a series of three images on the same frame can be
recorded. The technique not only shows different wing
positions within a relatively short space of time but also
enables insect take-off and landing procedure to be
observed. This little butterfly was found in the forests of
Venezuela.

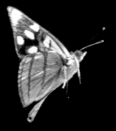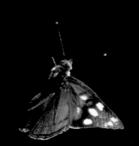

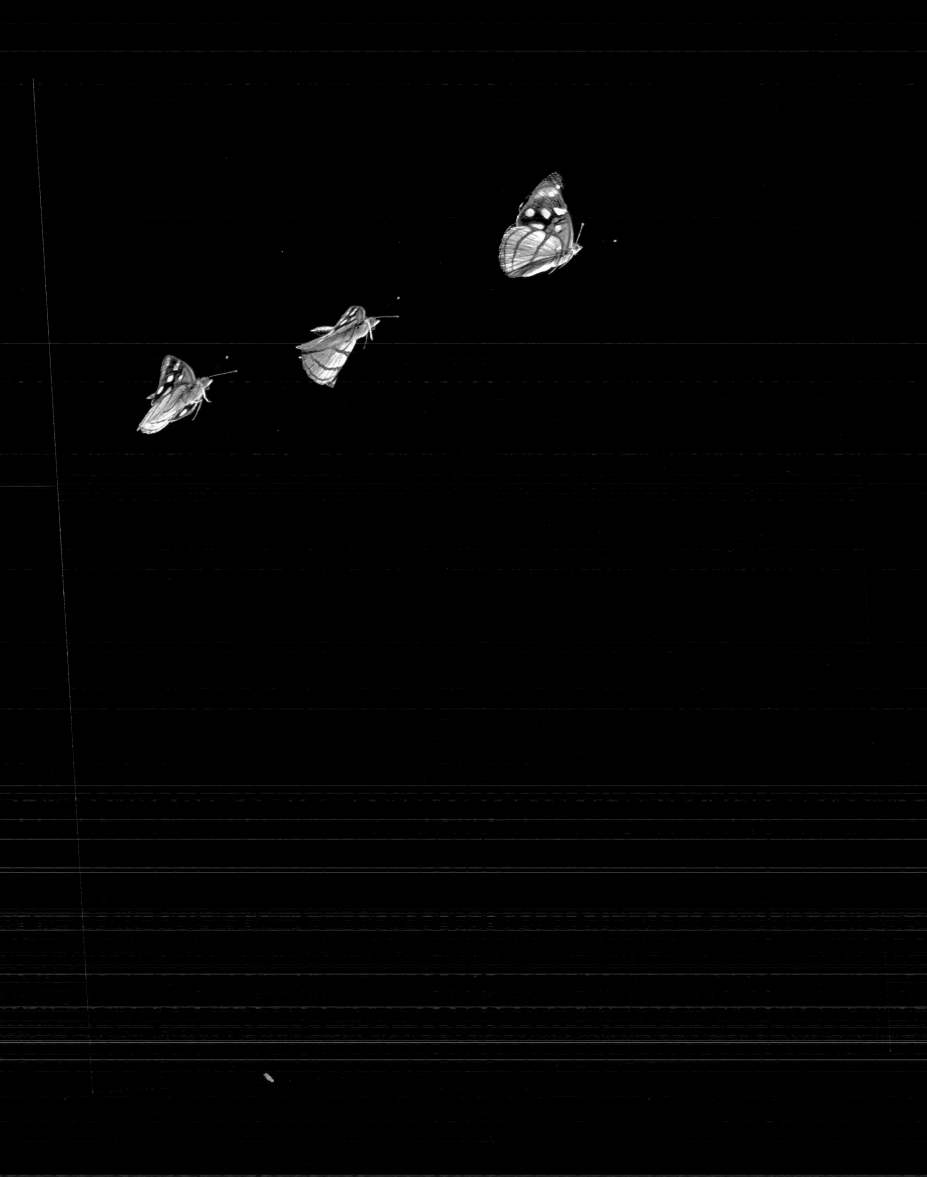

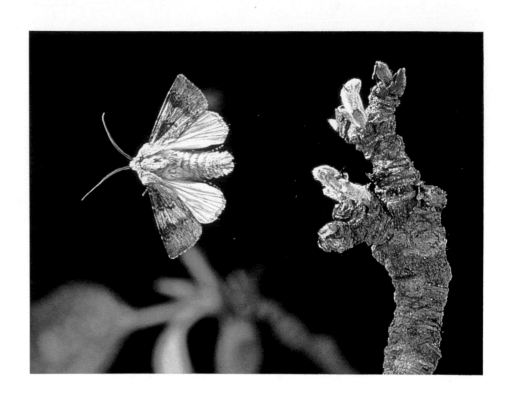

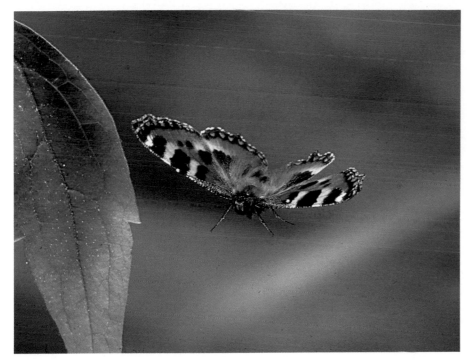

Opposite
119 Archer's dart
The moth has just taken off from an
apple branch. The archer's dart is a
member of the largest family of moths,
the owlets (noctuids). Although some
tropical species are brightly coloured
and others have wing spans of ten or
twelve inches, the large majority are
drab, medium-sized moths with
cryptic wing patterns that merge into
natural surroundings.

Left
120 Small tortoise-shell
Compared with the majority of insects
the wing-beat frequency of most
butterflies is low (8-20 cycles per
second); nevertheless, to arrest such
wing movement on film, a flash speed
of at least 1/10,000 second is needed.

The small tortoise-shell is one of the
commonest butterflies found in Britain
and Europe. It seems equally at home in city
gardens, woodlands or alpine meadows.

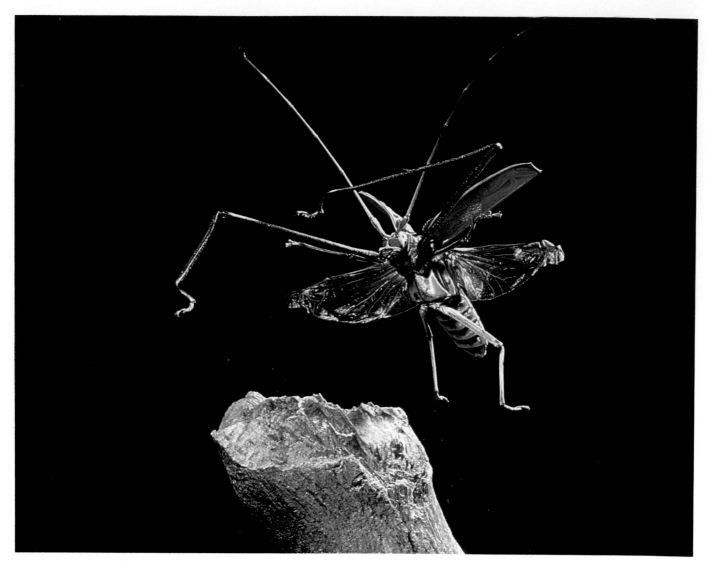

121 Harlequin beetle
A gigantic beetle from the Venezuelan tropical forests lifts off from a decaying stump. Beetles, especially large ones, are slow and clumsy fliers—this one needed about half a minute to unfold its wings and prepare for flight.

Opposite
122 Bumblebee
In the past, scientists have often puzzled as to how bumblebees, with their relatively heavy bodies, manage to become airborne at all, and yet these creatures can be found flying in cold, wet, and windy weather, when other insects have been grounded. Certainly bumblebees tend to be clumsy on the wing when flying slowly, but they are much more agile once airspeed has been gathered. This picture shows the creature winging its way at full speed between flowers in the herbaceous border.

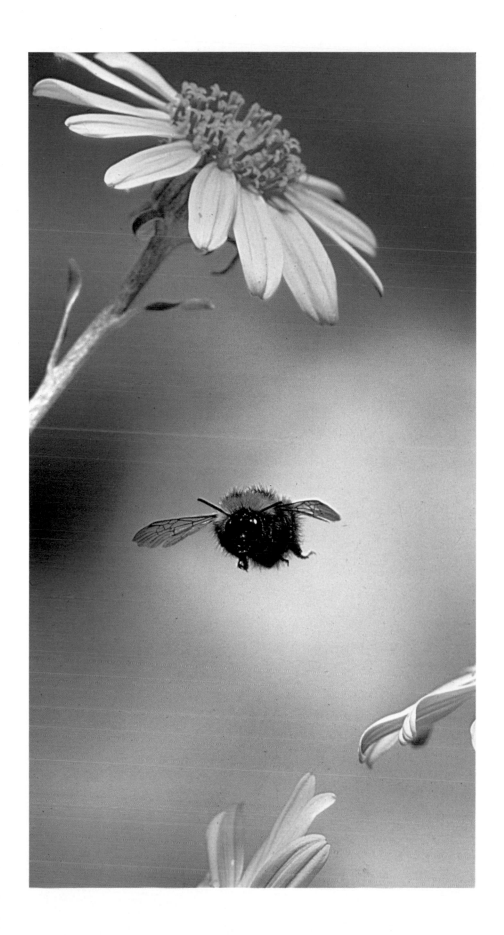

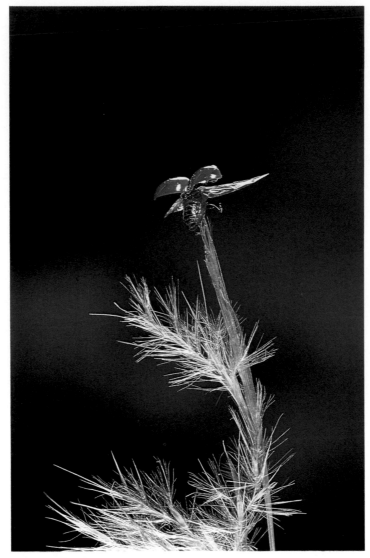

123 Ladybird
The wing-beat frequency of beetles varies considerably from about 30 c.p.s. to perhaps well over 150 c.p.s., depending on the insect's size. This ladybird, from the Everglades in Florida, has just lifted its wing-cases in preparation for take-off.

Opposite
124 Falling cat
People have often wondered how a cat always manages to land on its feet after falling—it all occurs so quickly that it is impossible to see what actually happens. This fascinating sequence of high-speed photographs demonstrates exactly what stages are involved.

As soon as the cat begins to fall, it jack-knifes its body by bending at the waist. Next, it rotates the head and front part of its body to face downwards—so flexible is a cat's spine that it can twist the length of its body nearly 180 degrees. Once the front end is facing the ground, the rear end of the body follows so that by the time the animal meets the ground it lands on all fours. Most of the action takes place in the first few hundredths of a second.

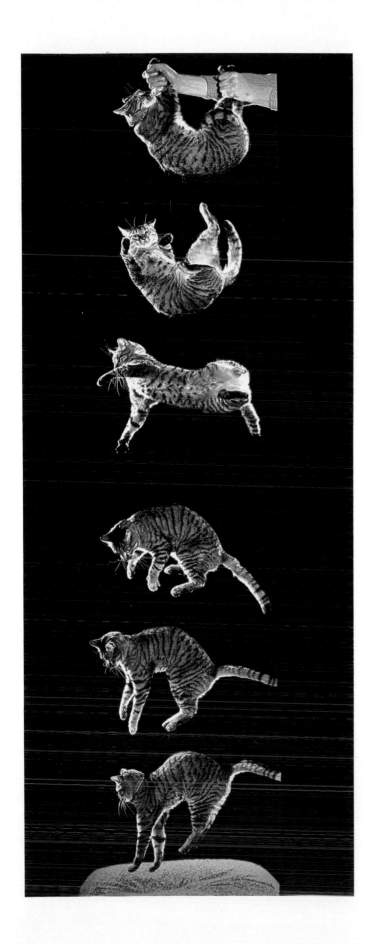

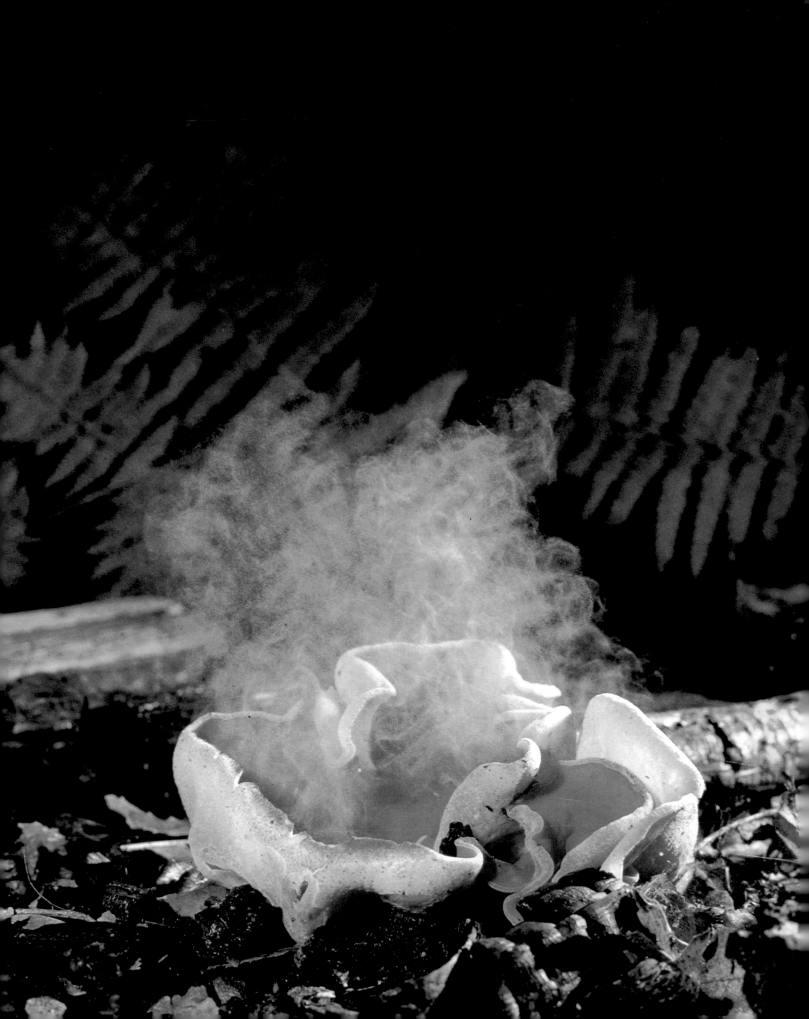

125-127 Fungi discharging spores

There are several species of fungi which discharge spores into the air when hit by drops of water. Electronic flash provides an ideal source of illumination for showing this up, but because the cloud disperses in a leisurely manner, and the individual spores are too small to be resolved by the camera at these low image scales, true high-speed is not really necessary.

The picture on the left shows a cup fungus; the other two are puff-balls, pl.126 being a stump puff-ball and pl.127 a common puff-ball. The more familiar common puff-ball is at first snow-white, but as it matures and the spores ripen it turns brown. Although the discharge of spores is usually triggered by rain falling on the spore-filled sac, the mechanism can also be set off by wind or by small mammals shuffling by.

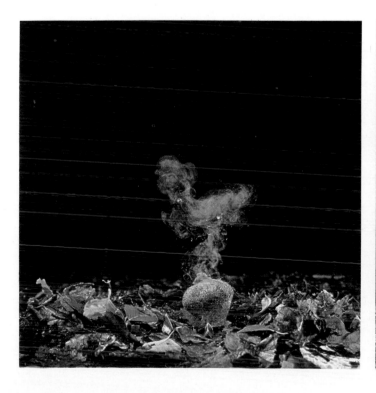

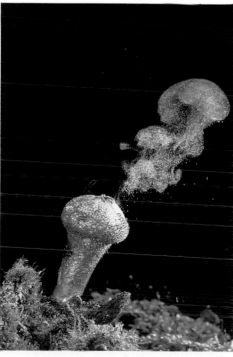

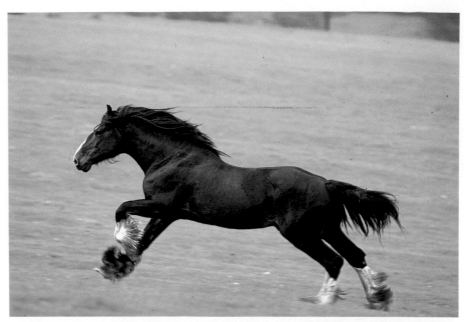

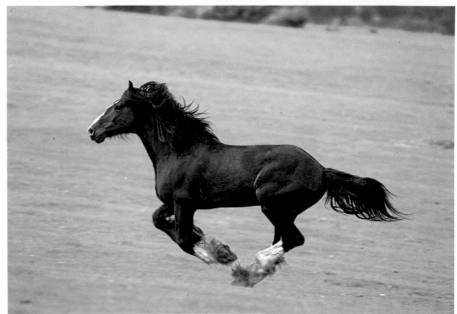

Two horses
128, 129 Taken at around 1/250 second, these two photographs of a galloping cart-horse can hardly be described as truly high-speed, but when compared with the pioneering efforts of Marey and Muybridge (see opposite) the improvement in modern films and cameras is plain to see.

Opposite
130 This series of twenty-four photographs, taken by Eadweard Muybridge in 1881, showed the world exactly how a horse jumps over a gate. The pictures appeared in his classic book *Animals in Motion*.

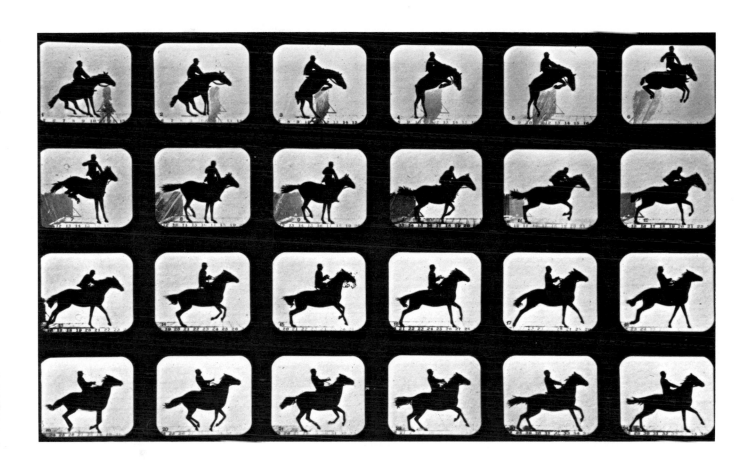

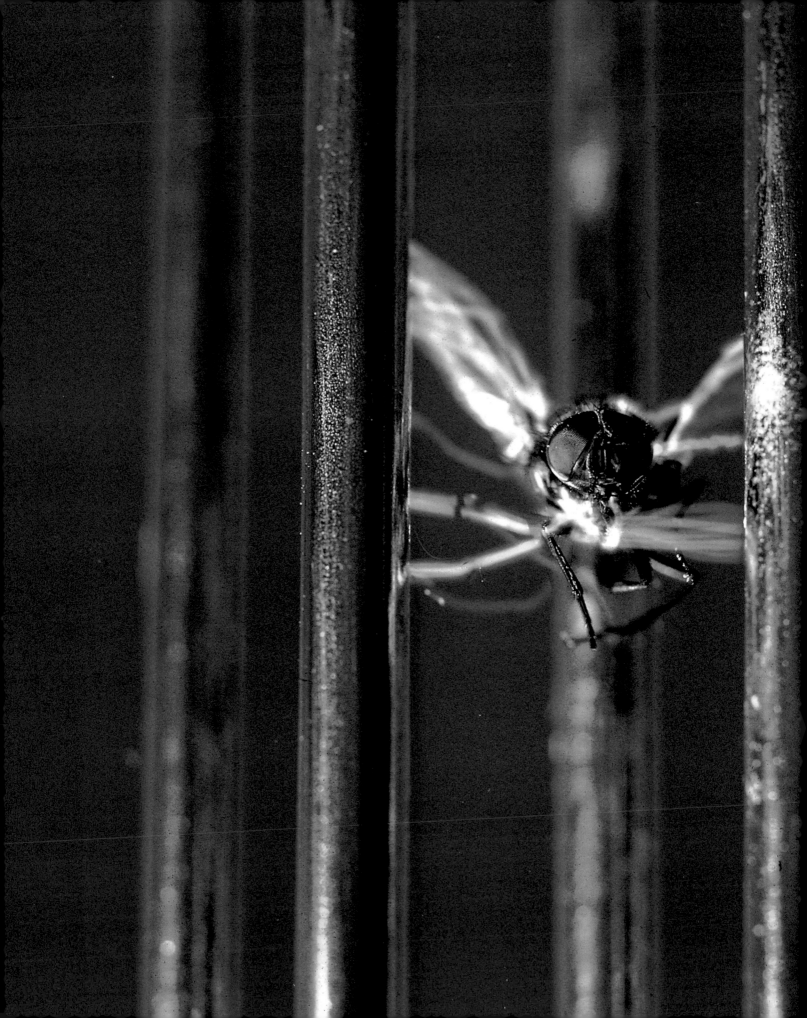

131 Electrocution of housefly
This bizarre photograph shows a housefly at the instant of electrocution, as it wanders into an electric fly-trap. The fly is attracted to the device by ultra-violet light emitted by special lamps at the back of the trap, but to get there the insect has to fly between two grids about ten millimetres apart. As the doomed creature flies into this gap, the insulation of the air space breaks down, allowing a 4,500-volt electrical charge to jump from one grid to the other via the fly. The white streaks are the bolts of 'lightning' generated by this lethal trap. On the left, the shape of the fly's wing is outlined by the discharge. The photograph was made by combining a ¼-second time exposure with high-speed flash.

132 Frog leaping into water
Caught in mid-leap, a common European frog is making for the comparative safety of the water. It takes about 1/10 second for a frog to extend its powerful hind-legs, reaching a maximum speed of around 60 miles (*c.* 96km) per hour. On land its leap may propel the creature twelve times its body length.

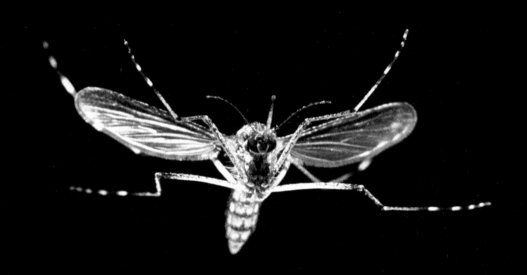

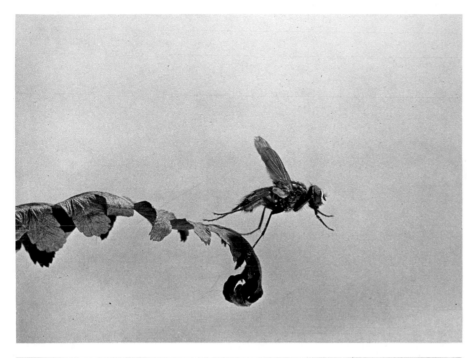

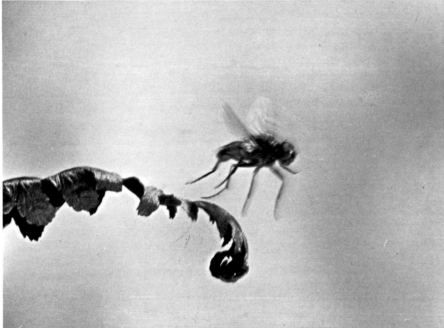

Opposite
133 Female mosquito in flight
Small insects such as mosquitoes can
be particularly irksome to photograph
in flight. They tend to have very high
wing-beat frequencies—mosquitoes
about 600 c.p.s. and midges around
1,000 c.p.s. Thus, the wings of a gnat
may move from the fully up position
down to the bottom of their stroke and
back up again, all within normal flash
speed. Tiny insects present other
problems too. Apart from the obvious
difficulty of detecting them at a precise
point in space, the lack of depth of
field has to be contended with. In this
picture the depth is only just sufficient
to cover the distance between the head
and the leading edges of the wings.

Left
**134, 135 High-speed compared with
normal flash**
These two photographs illustrate the
advantages of using high-speed flash
for photographing insects in flight—in
this case a housefly taking off. The
speed of flash in pl.134 was 1/25,000
second, while 1/1000 second was
used in pl.135. Bear in mind that the
fly has only just taken off; had it been
flying at full speed the difference
would have been even more marked.

Overleaf
136 Thunderstorm
Recording thunderstorms on film can
hardly be classified as high-speed
photography, but the source of light
energy is similar to the flash generated
inside an electronic flash tube. Far
from being instantaneous, a bolt of
lightning pauses for about 50
microseconds each time it changes
direction as it works out a path to the
ground. When it is about half-way
down, a further flash shoots upwards
to meet it. Only then can the main
charge of up to 300 million volts be
released. So if you are unfortunate
enough to be struck by lightning, note
that the charge will flow up your body
and out through the top of your head!

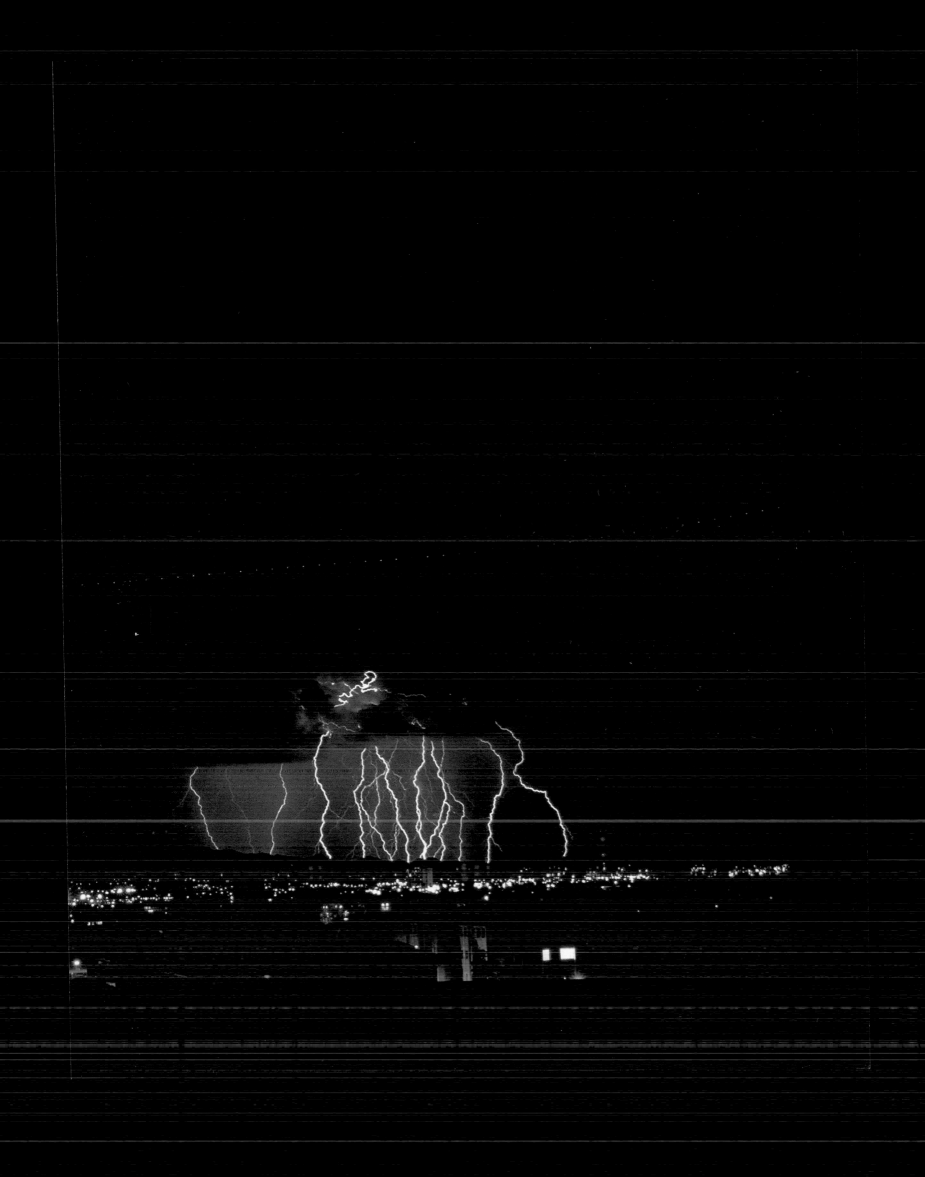

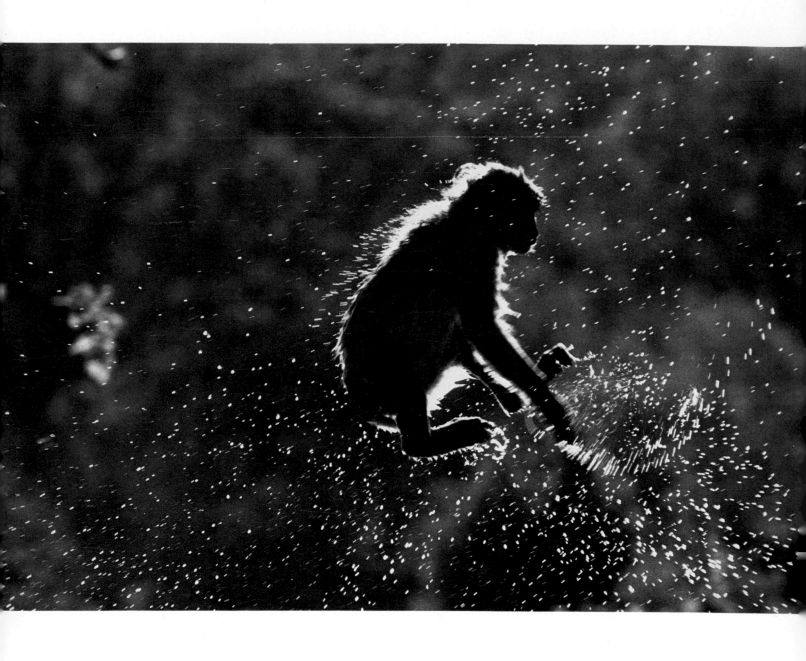

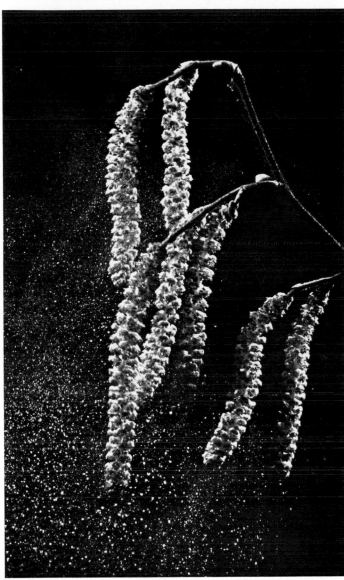

Opposite
137 Leaping ape
After bathing in a shallow pool of water, a barbary ape leaps from one rock to another (just out of the picture). A shutter speed of 1/1000 second shows each drop of water glistening in the sunlight.

Left
138 Catkins shedding pollen
In the field, spring breezes or disturbance by birds cause pollen to be shed from catkins. In the photographic studio dispersal can be encouraged by a sharp tap with a pencil.

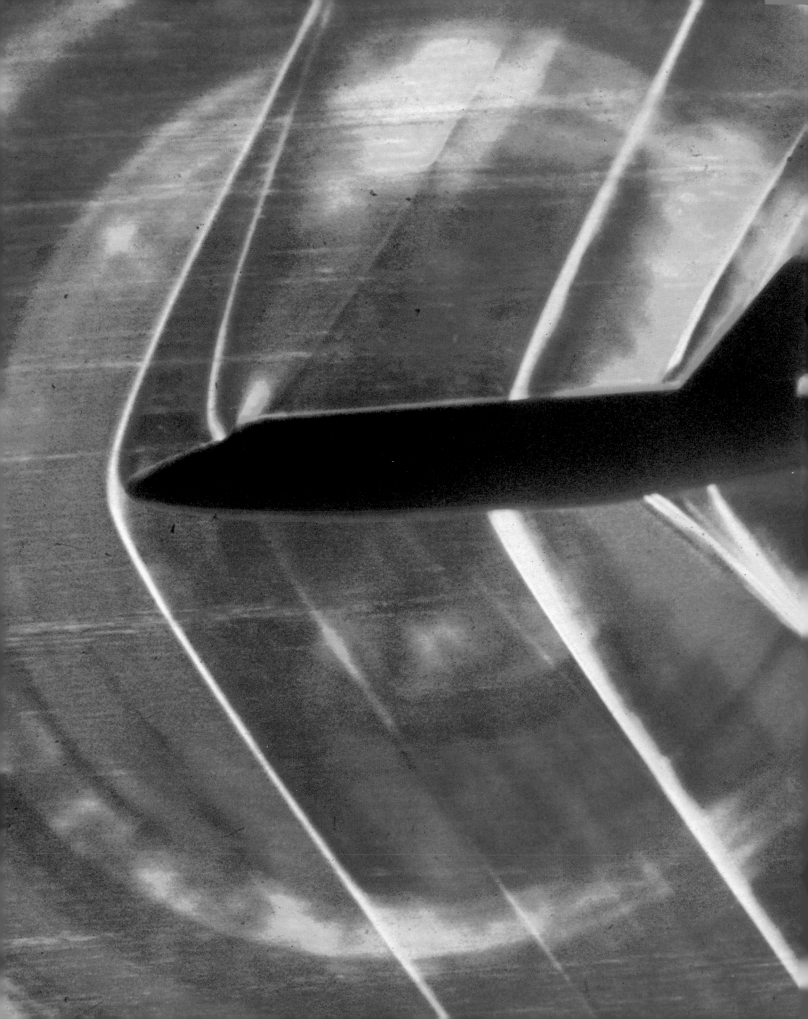

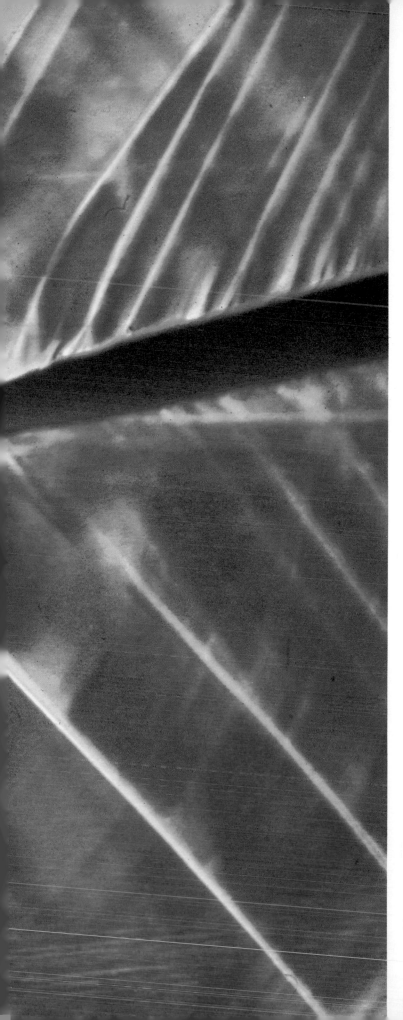

5 High Tech

139 Shuttle wind-tunnel test
Profile view. See pl.1 for caption.

The well-known dealer in coins, Spink of London, wanted a poster to publicize a major exhibition of antique coins (commemorating the anniversary of the succession of his Highness the Emir of Qatar). The plan was to show gold coins, some of them nearly 2,000 years old, falling from heaven.

Although the idea was simple, there were conflicting requirements. The coins not only had to be blurred to suggest movement, but they also needed to be recognizable—every letter had to be legible. The best way to achieve this was by taking a number of exposures, and combining the characteristics of both high-speed flash (1/25,000 second) and low-speed flash (1/600 second). As a result, some of the coins are critically sharp and others show movement. Synchronization was effected by allowing the coins to fall through a beam of light.

There is a strong symbiotic relationship between photography and science. Scientists and engineers use photography as a tool to help them in their research and development projects, while photographers borrow tools and techniques developed for scientific research to create a variety of pictorial images. These last few pages include a number of fascinating and attractive images arising from each approach.

Whether the pictures were intended to be scientific, pictorial or both, the range of exposure times represented by them varies enormously. Because some of the subjects were self-luminous, they were taken at high shutter speeds, but others were exposed with flash durations ranging from one thousandth to one billionth of a second.

One relatively new field involving photography in a major way is holography. Holography seems almost like magic; it is certainly difficult to imagine anything less plausible. Instead of forming an image in the conventional photographic way, a complex arrangement, often without a lens, but including a laser, mirrors and of course a subject, produces a totally nondescript pattern of fuzzy whorls and blobs on a photographic plate. If this plate, or hologram, is then set up and viewed in the right way, again by using the laser, an absolutely lifelike three-dimensional image is formed. But unlike a normal 3D image, it is possible to see round corners—simply shifting one's viewpoint brings new areas of the image into view.

With holography, it is not only possible to expose many 'photographs' on the same plate, for if the plate is dropped and shatters, each fragment contains all the information necessary to provide a full three-dimensional image of all the pictures taken on it! It works by interference.

Included towards the end of this section are two examples of a particularly weird form of holography involving high-speed.

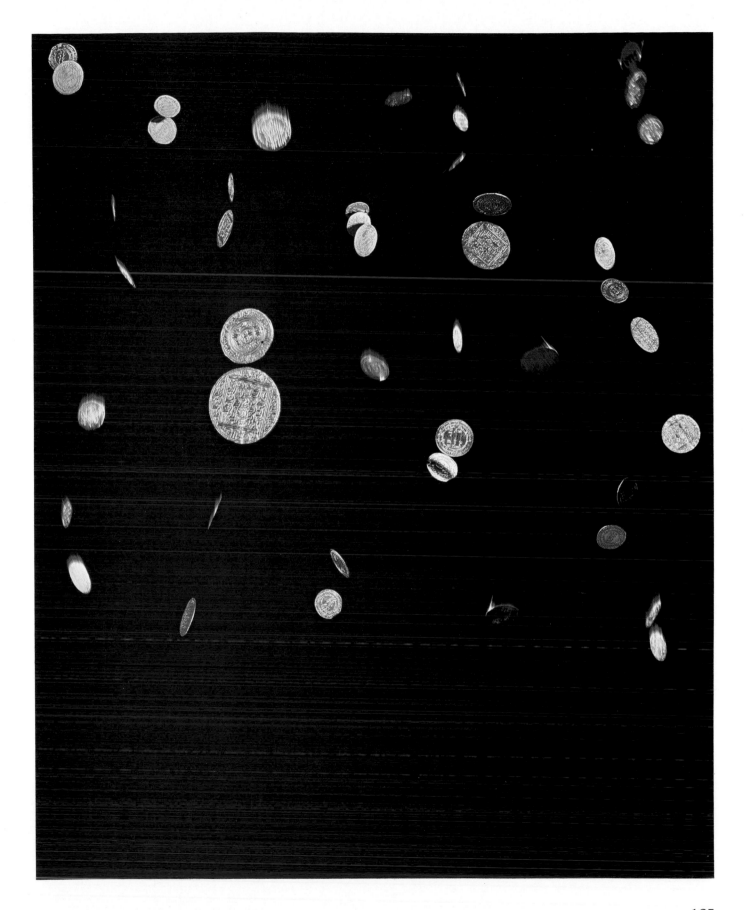

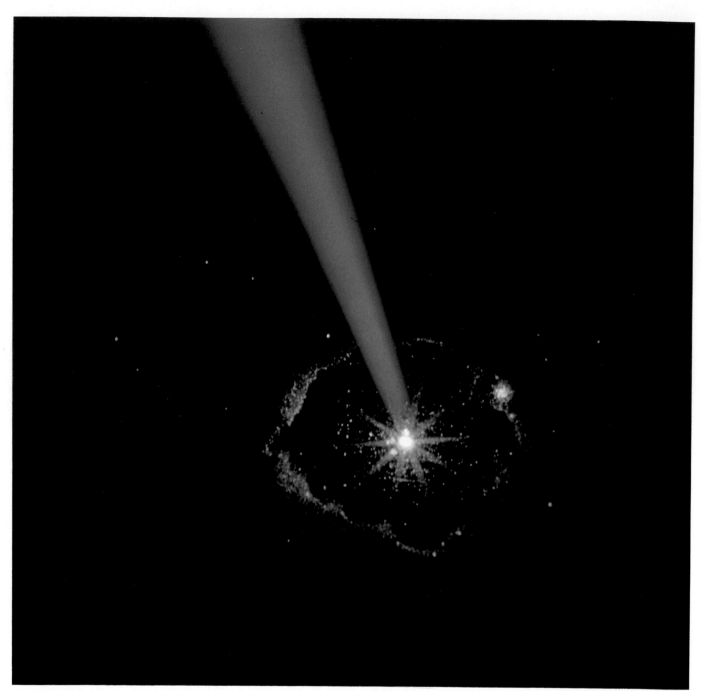

Laser beams

141 Like a ray from some extra-terrestrial source, an argon laser beam produces an explosive effect. In fact the laser is being used to vaporize minute particles of matter for analysis by sophisticated spectroscopic methods. The original transparency has been enlarged about one hundred times to achieve this effect.

Opposite

142 As well as having a host of scientific uses, the laser beam is immensely useful in industrial and surgical procedures. This is a close-up of the powerful laser light from a carbon-dioxide laser plant burning a path through a thick pane of plate-glass at high speed, cutting and fusing the edges at one and the same time.

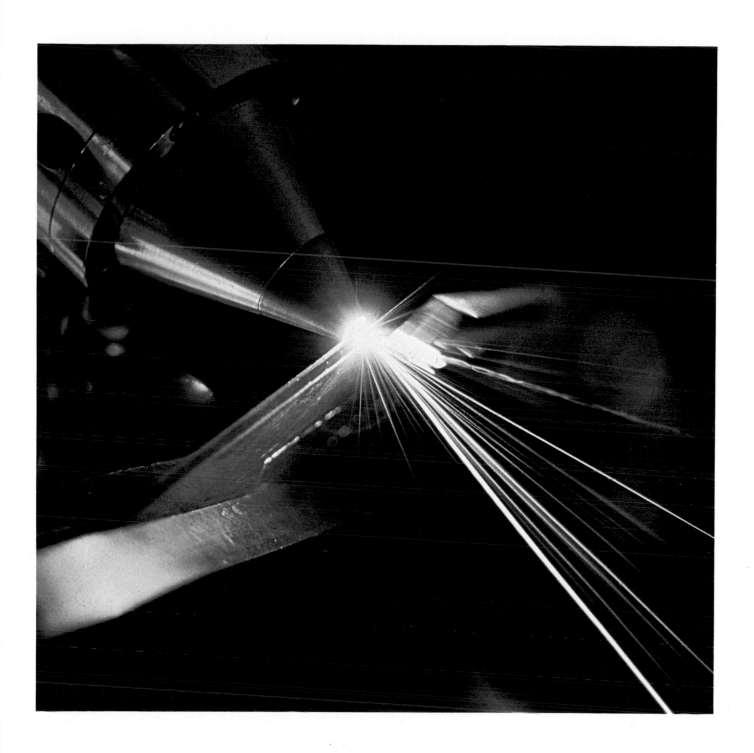

143 Insulator testing

The efficiency of high-voltage insulators can decline drastically if they get covered with salt or dirt in coastal and industrial areas, allowing currents to leak over their surface.

The voltage producing the flash-over spark in this photograph was about 700,000 volts and lasted some five-millionths of a second. The photograph was taken in the high-voltage laboratory at the Electricity Council Research Centre.

Opposite
144 Fusion of TV tube face-mask

During the manufacture of a cathode-ray tube for colour television, a toughened glass face-mask is fused by flame to the neck of the tube. To ensure uniform heating and softening of the surfaces in contact, the glass components are spun around the jets of flame until the moment they fuse together. Rather than using flash, a high shutter speed was employed to obtain this picture.

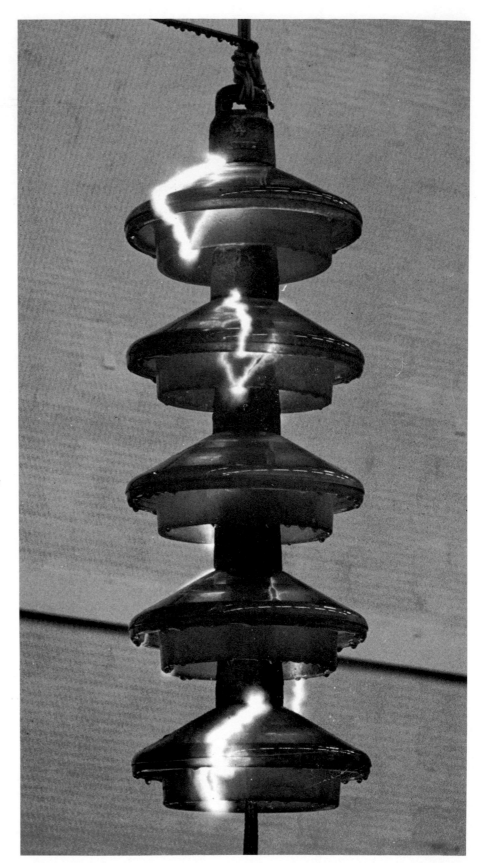

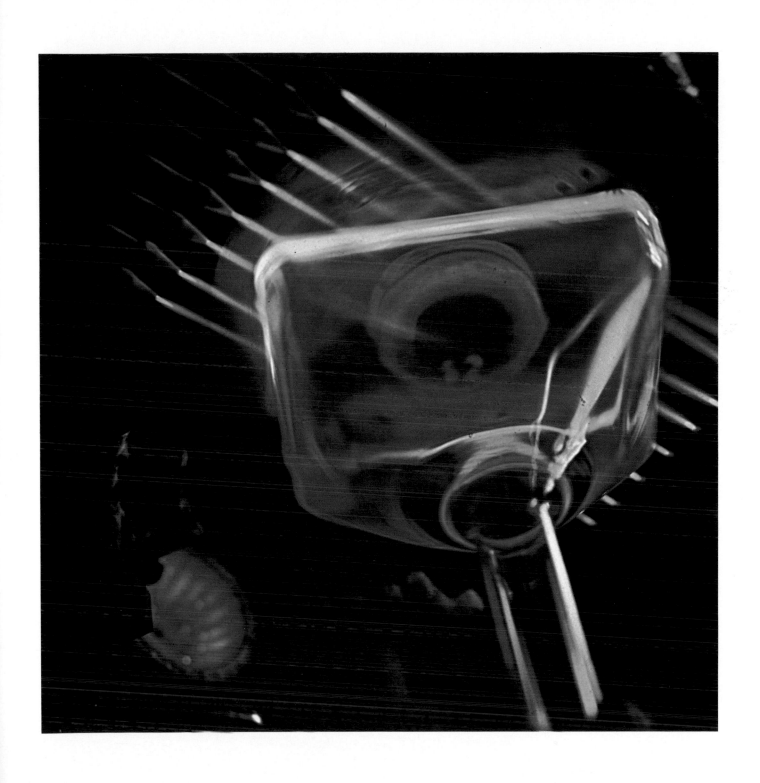

Overleaf
145 Flying hammer
High-speed stroboscopic lighting has
created an intriguing pattern of a ball
peen hammer in flight.

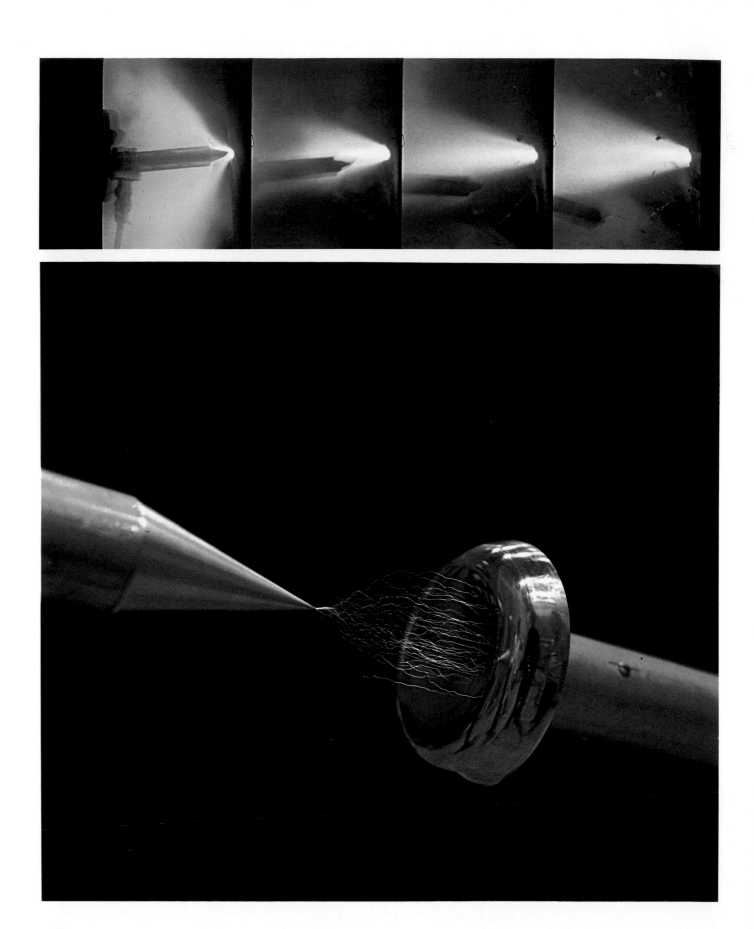

146 Handyman's nightmare
Some of us know what it is like to nail or drill through an innocuous-looking wall into an electric cable. New designs of underground cable are tested to check how they behave when driven into by a spike. The photographs here show an 11,000-volt cable being penetrated through its earthed shield. The pictures have been enlarged from frames taken on a high-speed cine camera.

147 Flash-over
High-voltage insulators on the pylons of overhead transmission lines are tested under a range of temperature and humidity conditions to assess their resistance to flash-over, the breakdown of their insulating characteristics. As the voltage is gradually raised, a point is reached when 'lightning' begins to strike across the horns adjacent to the ceramic insulator. A shutter speed of 1/1000 second was used to retain the detail of the fine tracery.

148 X-rays
A remarkable picture of the varying intensities of X-rays generated when pairs of deuterium and tritium atoms (isotopes of hydrogen) are crushed together (in a glass pellet) and heated by twenty-four laser beams to 100,000,000°F. Under this mind-boggling onslaught the deuterium and tritium are transformed into helium, and part of their mass is converted to energy. The micro-explosion that results lasts for about a billionth of a second. This release of energy is a scaled-down version of what takes place in a hydrogen bomb, and it is part of a research project in which scientists are trying to harness the energy released by nuclear fusion.

Right
149 Fuel flow
Droplets of petrol flowing around the
needle valve of a carburettor
photographed at 1/2,000,000 second.

Below and opposite
150, 151 Deformed copper tube
In recording a three-dimensional
explosive deformation, use was made
of the technique of moiré topography
to provide three-dimensional informa-
tion. This technique uses a point or
line light source to project shadows
from an equi-spaced plane grating on
to the object, and the camera records
the moiré pattern formed between the
shadows and the original grating. The
moiré pattern is a contour line system
showing equal depth from the plane of
the grating provided the source and
the observing point lie on a plane
parallel to the grating. In this
experiment a high-speed cine camera
operating at 16,000 frames per second
recorded the fringe pattern as a copper
tube was rapidly deformed by an
explosive charge. The total time for the
event was less than 2 milliseconds.

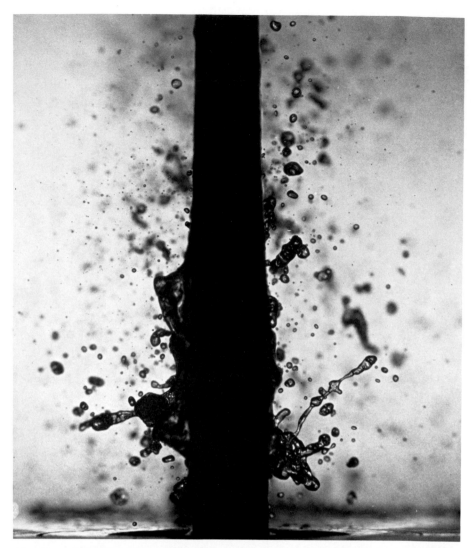

134

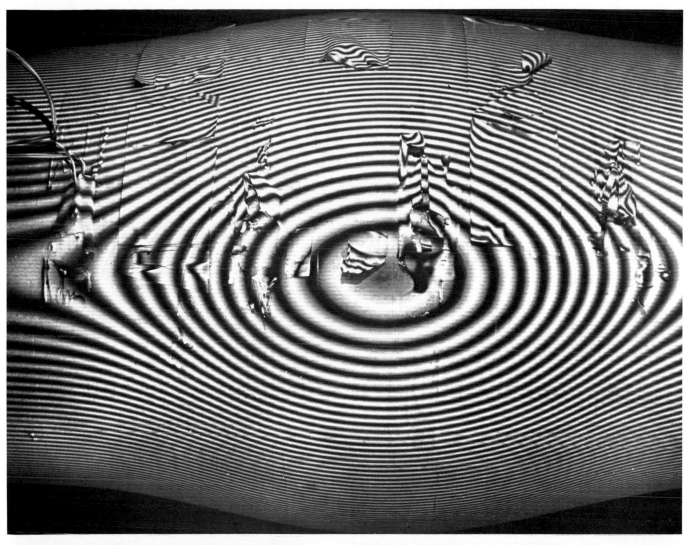

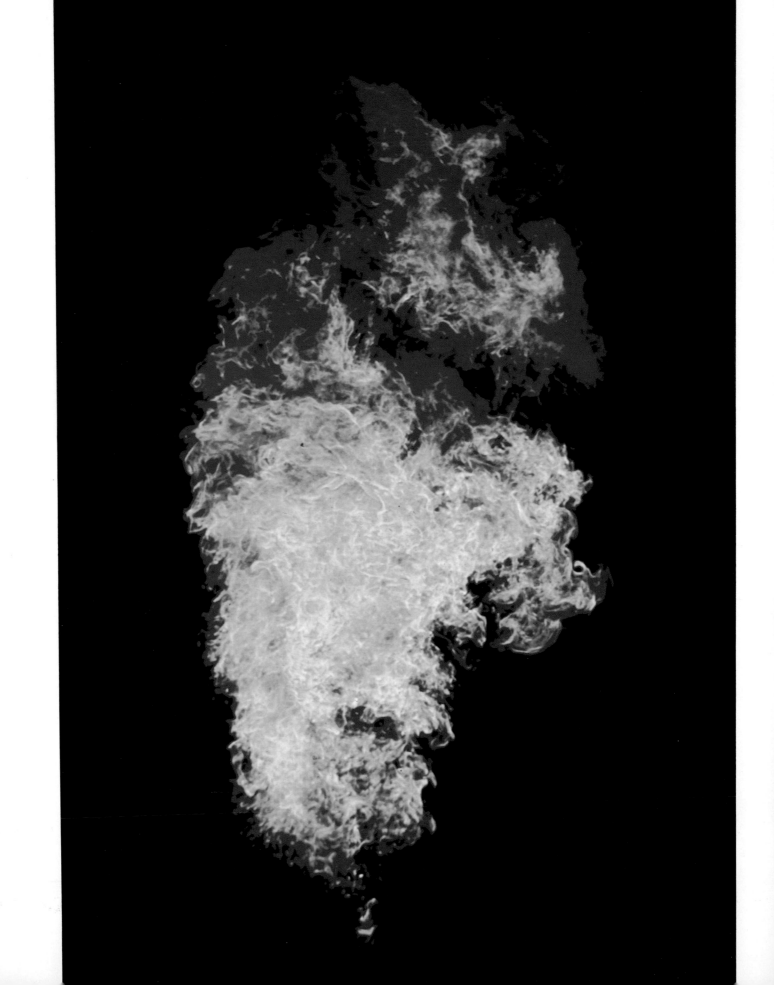

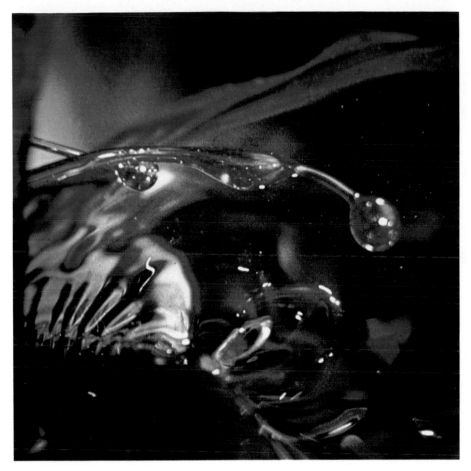

Opposite
152 Oil flare
The convolutions of a billowing flame
produced by the burning of waste
fuel-oil, captured in 1/1000 second.
The chief concern of the photographer
was to keep at a safe distance to avoid
scorching—hence a telephoto lens was
used.

Left
153 Cutting fluid
During the cutting of metals by
machine tools, a stream of fluid is
directed at the interface between metal
and tool. This permits fast precise
cutting by reducing friction. The fluid
is thrown off at some speed, often
forming a variety of jets and droplets.
The detail here was exposed at 1/1000
second.

Holograms

154 Double-exposure holography makes visible movements that are too small to be seen by the naked eye. The photograph shows the effect of a hammer-blow on the head of a man wearing a motor-cyclist's crash-helmet. The pattern of light and dark bands enables the movement of the eyeball, under the closed lids, to be calculated. A pulsed ruby laser was used as a light source. Two pulses of 25 nanoseconds duration, separated by 25 nanoseconds, were used to record the two exposures on one photographic plate. In one nanosecond (=1/1,000,000,000 second) light travels about a foot!

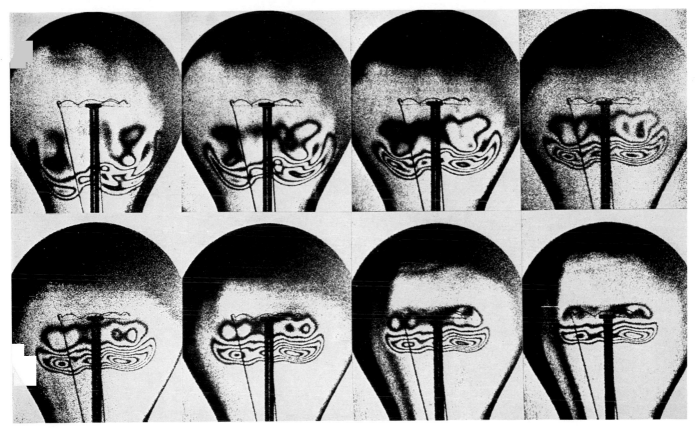

155 This series of eight photographs shows the development of a convective flow of gas in a domestic light-bulb as the current is switched on. The flow is totally invisible to the naked eye.

A sequence of double-exposure holograms was recorded on a single photographic plate, using a pulsed ruby laser as a light source. Each photograph shows one section of the three-dimensional image which is reconstructed from one double-exposure hologram. The interference pattern in each picture shows the changes in refractive index during the double-exposure interval of 20 milliseconds. The technique might be described as '4D' holographic interferometry, showing changes in refractive index in three dimensions, with time giving the fourth dimension.

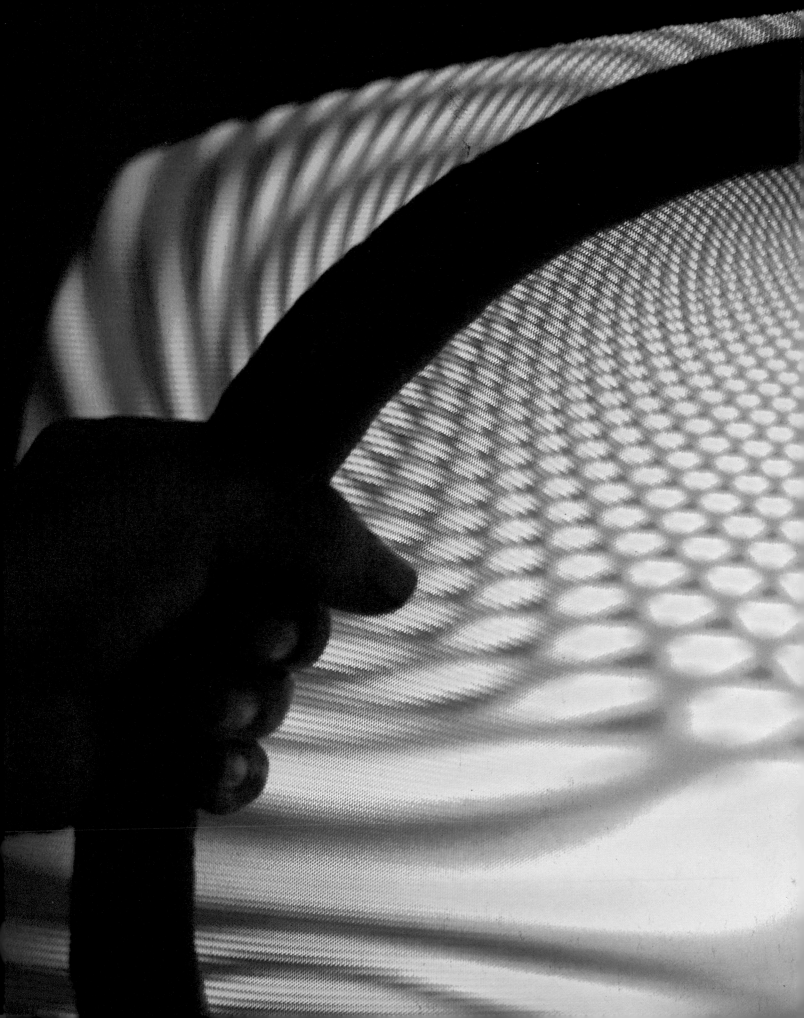

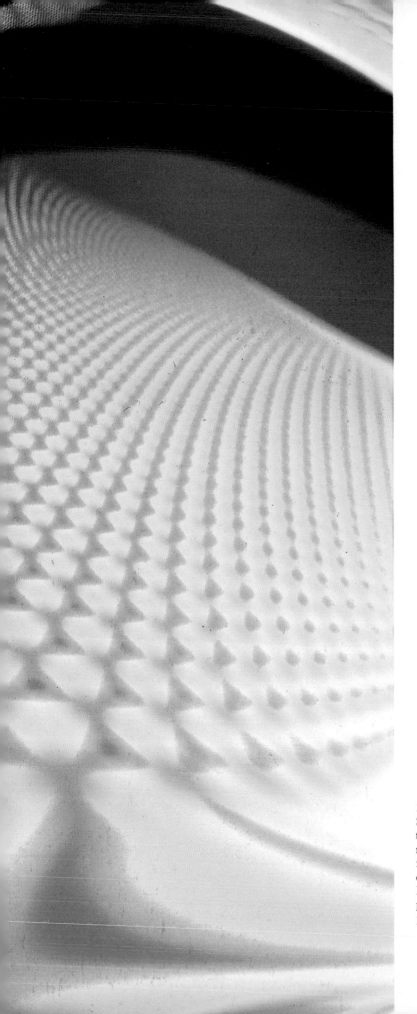

156 Testing a TV tube
Swiftly darting magnetic fields appear on a colour television tube during final testing, when a demagnetizing ring is applied to remove all traces of residual magnetic fields. The powerful magnetic pull of the ring distorts the colour pattern generated by the tube's electron beams. Exposure time was 1/1000 second, and the lighting was purely from the cathode-ray exciting the screen's phosphor dots.

Acknowledgments

The publishers would like to thank the following people for their help in compiling this book:
Dr Harold Edgerton of MIT, Michael Hadland and John Hinton of John Hadland (Photographic Instrumentation) Ltd, Dr J.E. Field, Peter Fuller, John Haybittle of Dunlop Ltd, John Rendall, Peter Sutherst of Kodak Ltd (also Kodak Ltd for use of their publication *Light Reading*), Stewart Lawrie of Reed Group Ltd, Richard Patterson of Nikon UK Ltd and John Ward of the Science Museum, London.

Ardea, London 101, 105-8, 128, 129, 137; Paul Brierley, Harlow, Essex 43, 77, 78, 141, 142, 144, 147, 152, 153, 156; David Castle/Electricity Council Research Centre, Chester 143, 146; Hugh Clark 102-4; The Daily Telegraph Colour Library, London 83, 92, 98, 100; Stephen Dalton *front jacket,* 4, 25, 27-9, 45-9, 52-71, 109-123, 131-5, 138, 140; Stephen Dalton/Oxford Scientific Films Ltd 72-4; Adrian Davies, Wallington, Surrey 126, 127; Dr Harold Edgerton/Science Museum, London 97; Dr Harold Edgerton/Science Photo Library, London 3, 19, 21, 79, 80-2, 91; T.G. Grover/Dunlop Ltd, London 94; John Hadland (Photographic Instrumentation) Ltd, Hemel Hempstead 6, 20, 22, 23, 26; John Haybittle/Dunlop Ltd, London 85-90; Kingston-upon-Thames Museum fig. 3; Kodak Ltd figs. 8-10; Ray Massey, London 31, 75; Terry Meekam/Art Directors' Photo Library, London 84; Jay A. Myrdal, London 5; National Physical Laboratory, Teddington (Crown Copyright) 154-5; Nature, Chamalières, France 32, 44, 124, *back jacket;* Nikon UK Ltd 24, 99; Oxford Scientific Films Ltd 13, 33, 125; Reed Group Ltd, Maidstone 34-5; Science Museum, London figs. 1-2, 5-7, 14-16, 76, 93, 95, 96, 130; Science Photo Library, London 1, 7-12, 17, 18, 136, 139, 145, 148; John Shaw, London 2, 30; Clive Streeter, London 50, 51; Transport and Road Research Laboratory, Crowthorne, Berks. 36-42; Nick Welsh/National Engineering Laboratory, East Kilbride 149-51.

Stephen Dalton's pictures are available exclusively from the Natural History Photographic Agency, Little Tye, High Street, Ardingly, Sussex.

Index